FEDERICO ZERI (Rome, 1921-1998), eminent art historian and critic, was vice-president of the National Council for Cultural and Environmental Treasures from 1993. Member of the Académie des Beaux-Arts in Paris, he was decorated with the Legion of Honor by the French government. Author of numerous artistic and literary publications; among the most well-known: *Pittura e controriforma*, the Catalogue of Italian Painters in the Metropolitan Museum of New York and the Walters Gallery of Baltimora, and the book *Confesso che ho sbagliato*.

Work edited by FEDERICO ZERI

Text
based on the interviews between
FEDERICO ZERI and MARCO DOLCETTA

This edition is published for North America in 2000 by NDE Publishing*

Chief Editor of 2000 English Language Edition
ELENA MAZOUR (*NDE Publishing**)

English Translation
DIANA SEARS

Realization
ULTREYA, MILAN

Editing
LAURA CHIARA COLOMBO, ULTREYA, MILAN

Desktop Publishing
ELISA GHIOTTO

ISBN 1-55321-017-4

Illustration references

Bridgeman/Alinari Archives: 18b, 23ad, 42a, 45/X.

Giraudon/Alinari Archives: 4b, 5b, 6b, 14b, 18ad, 20a-c, 23as-b, 29d, 31, 32b, 34a, 35a, 40a, 41as-bs-d, 43d, 44/V-XI, 45/I-II-IV-VI-XII.

Luisa Ricciarini Agency: 4a, 15, 21, 29s, 37, 38b, 44/II-XII, 45/ XII.

RCS Libri Archives: 1, 2, 2-3, 5ad, 6a, 6-7, 8-9, 9a, 10a, 10-11, 12, 13as-d, 14a, 16, 17s-bd, 19, 20b, 22b, 24, 24-25, 26-27, 27a, 28bs, 33as-ad-b, 34b, 36a-b, 40b, 44/I-VI-VII-IX-X, 45/III-V-VII-VIII-IX-XI-XIV.

R.D.: 5as, 9b, 10b, 13bs, 17ad, 18as, 22a, 27b, 28as-d, 30, 32a, 35b, 38a, 39, 42b, 44/III-IV-VIII.

Team: 43s.

Printed and bound by Poligrafici Calderara S.p.A., Bologna, Italy

* a registered business style of NDE Canada Corp.
15-30 Wertheim Court, Richmond Hill, Ontario
L4B 1B9 Canada, tel. (905) 731-1288

The captions of the paintings contained in this volume include, beyond just the title of the work, the dating and location. In the cases where this data is missing, we are dealing with works of uncertain dating, or whose current whereabouts are not known. The titles of the works of the artist to whom this volume is dedicated are in blue and those of other artists are in red.

TOULOUSE-LAUTREC
AT THE MOULIN ROUGE

A bohemian aristocrat, Henri de Toulouse-Lautrec portrayed the life of the theaters, night spots, and brothels where he spent most of his time in Paris at

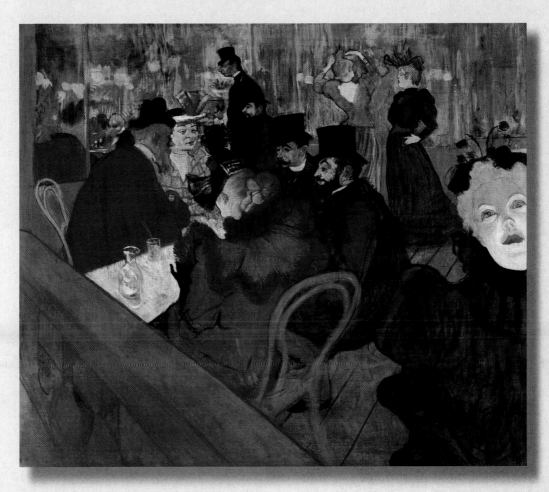

the end of the nineteenth century. His extraordinary capacity for observation, his pungent spirit and realistic treatment of subjects make him one of the most resolutely modern painters of his era.

A BOHEMIAN ARISTOCRAT

AT THE MOULIN ROUGE
1892-93

● Chicago, Art Institute, Helen Birch Bartlett Memorial Collection (oil on canvas, 123x141 cm)

● While Impressionist painting was celebrating its triumph, the French artist Henri de Toulouse-Lautrec became the chronicler of the sparkling lights of the night spots, the theaters, the circuses, the brothels in the last years of nineteenth century Paris. An aristocrat, nervous and deformed, he was an untiring observer of contemporary society. Satirical artist and forerunner of publicity designers, Toulouse-Lautrec invented the *affiche* (poster).

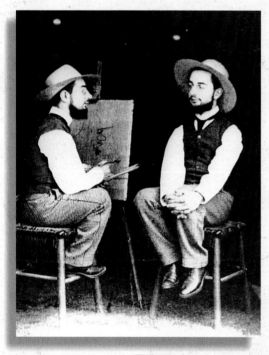

◆ HENRI DE TOULOUSE-LAUTREC
The artist (Albi, 24 November 1864 - Malromé, September 9, 1901) in a portrait done in 1892. Lautrec loved to be photographed in costume or - as here - with photomontages. Son of two first cousins, he was delicate from birth, and his health was aggravated by two falls from horses that arrested the growth of his legs. On the right, *At the Moulin Rouge*, depicting the most famous Parisian night spot in the years of the artist's activity.

● *At the Moulin Rouge* is perhaps the most problematic of his entire production, and it is one of a vast series of paintings dedicated to the dance halls then in vogue in Montmartre. For a period of over five years, from the end of the 1880s to the early 1890s, the places, like the circus, launched by the commercial system of the Parisian show world in continuous movement, were the principal subject of Toulouse-Lautrec's pictures, appreciated in exhibitions and fetching high prices in private dealings.

● The perpetual *kermesse*, the masked balls, the gas lights, the electric lighting, all captured the artist's fantasy.

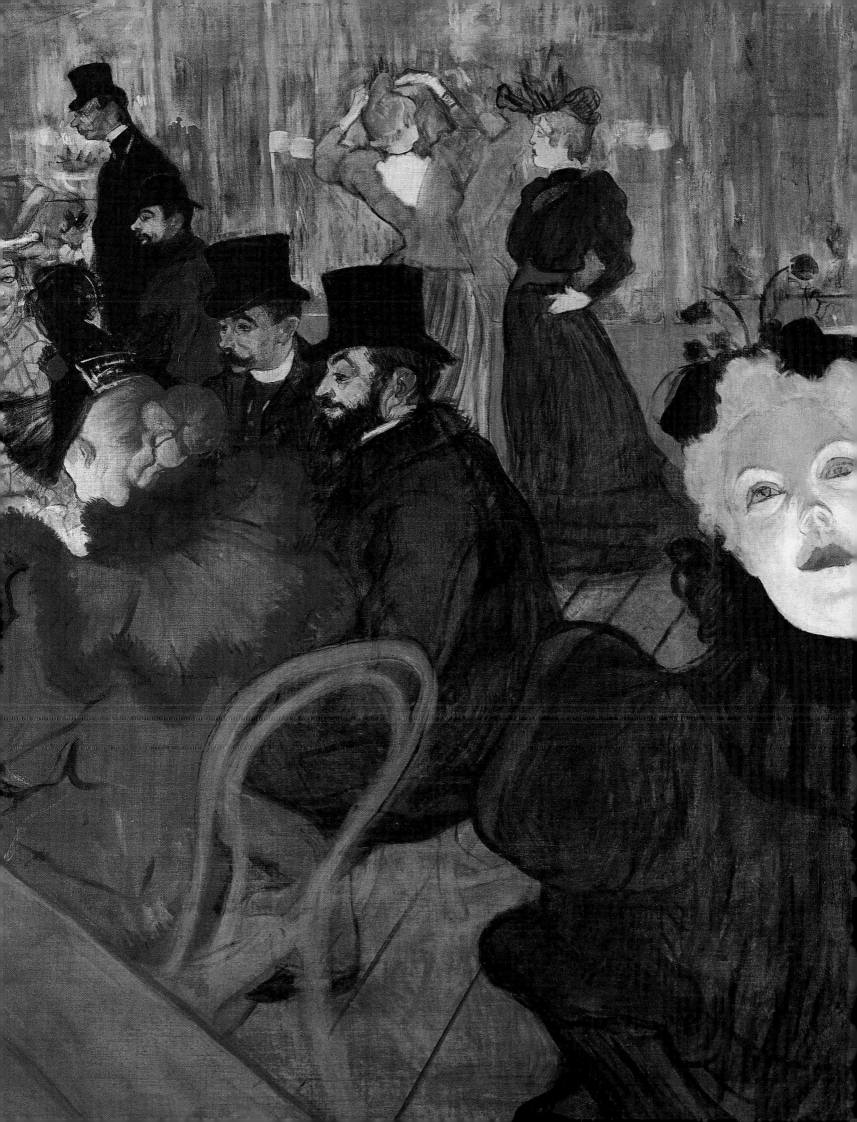

AN INEBRIATING ATMOSPHERE

On October 5, 1889, the *Moulin Rouge* was inaugurated at Place Blanche then on the outskirts of Paris; this dance hall replaced the *Reine Blanche* of the Second Empire era. To launch the new night spot and attract a well-to-do clientele, but also to give life to the peripheral area where it was located, the owners adopted modern publicity techniques, including posters and leaflets as well as announcements and photographs of the show people in the popular press.

● At the *Moulin Rouge*, with both gas and electric lighting, the curtain opened every evening at 8:30 on a stage with alternating *concert-spectacles*, provocative and masked dancers, in perpetual movement which assured performances that were always the latest fashion. The dance popular at the time, the *chahut*, made this and other night spots famous. Not a new dance - it had been popular during the Restoration - it was replaced by the *can-can*. But, while in the latter the dancers mostly raised and twirled their skirts and underskirts, in the *chahut* the attraction was the frenetic high kick of the legs, often showing a view up past the top of the thighs. The two main movements in the dance are the *grand écart* and the *quadrille naturaliste*, based on kicking the legs high with a vertical split at the end.

● The young Henri de Toulouse-Lautrec suddenly found himself before a modern popular subject and spent most of his evenings in the *chahut* dance halls.

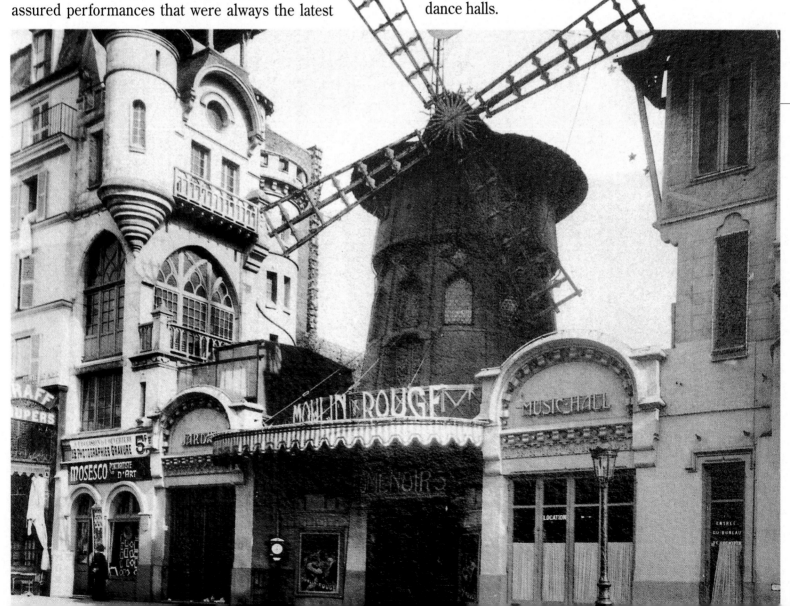

◆ GEORGES SEURAT
Chahut
(1890, Otterlo, Rijksmuseum Kröller-Müller). This painting by the expert of *Pointillisme*, exhibited at the *Salon des Indépendants* in Paris in 1890, gives a bold presentation of a moment of the *chahut* and was interpreted at the time as ironical criticism of the Montmartre environment.

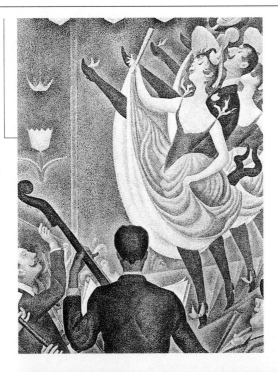

◆ JULES CHÉRET
Bal au Moulin Rouge
(1889, Paris, Musée de l'Affiche et de la Publicité). At the time Jules Chéret was the most famous *affichiste*, the inventor of the ideas for almost all the publicity for the Montmartre night spots. Simultaneously Toulouse-Lautrec also created publicity posters for shows and night spots, but with more modern and profane expression.

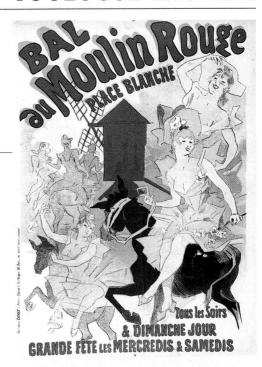

◆ THE MOULIN ROUGE
This photograph, conserved in the National Library in Paris, shows the exterior of the *Moulin Rouge* in rue de Pigalle at the end of the nineteenth century. These night spots were founded with the intention of commercial exploitation of the large *boulevards* in the city center as well as of the avenues in the peripheral working class suburbs. The oval at the top of the facing page shows a group of dancers doing the *chahut*.

◆ DANCE AT THE MOULIN ROUGE (GOULUE AND VALENTIN-LE-DÉSOSSÉ) (1895, Paris, Musée d'Orsay). The scene represents the dance show of *la Goulue* (the Glutton), the stage-name of Louise Weber, the dancer and actress discovered by the *impresario* Astruc who saved her from her destiny as a washerwoman. From 1889 on she was the major attraction at the *Moulin Rouge*.

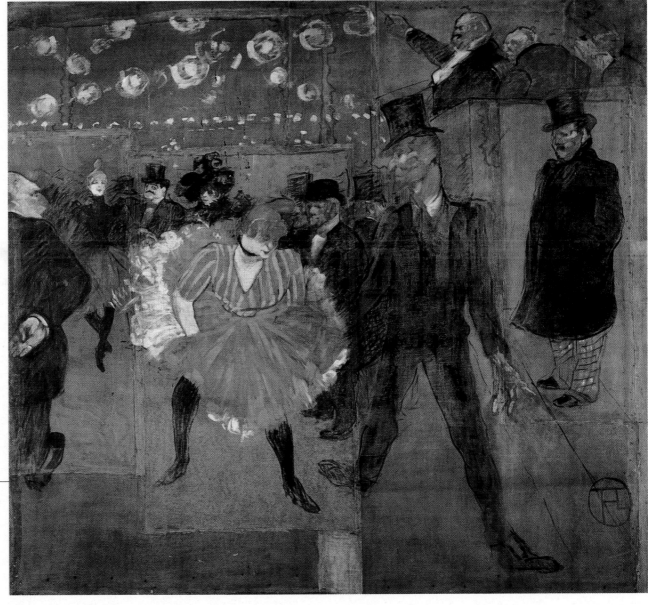

AN ALIENATING WORLDLINESS

Clearly conceived as an especially important painting, both for its size and composition, *At the Moulin Rouge* represents a group portrait with the artist and some of his friends mingled among a group of women, regulars at the dance hall.

● Toulouse-Lautrec and his cousin Gabriel Tapié de Céleyran appear in the background; the woman arranging her hair at the mirror is *la Goulue* ("the Glutton"), the stage-name of the dancer Louise Weber, who apparently got the nickname because of her habit of emptying clients' glasses. In the foreground around the table are gathered, from left to right, the literary dandy Edouard Dujardin, La Macarona, the photographer Paul Sescau, and the champagne merchant Maurice Guibert. There is some uncertainty regarding the red-haired woman portrayed from behind. The most common hypotheses identify her as the dancer May Milton or Jane Avril.

● Between the end of 1892 and the beginning of 1893 Toulouse-Lautrec devoted himself assiduously to paintings of the *Moulin Rouge* and the dancers in the show.

● The painting has the characteristics of a private picture, immersed in a spectral atmosphere. Although his friends are intelligent gentlemen of elevated social condition, the artist portrays them as tired and superficially worldly. The women occupy a marginal position, on the sides of the masculine triangle, because their presence is requested and paid for, but not their company. No one is talking, no gazes cross: a desolate atmosphere of social alienation dominates the scene.

● The entire picture reflects the strong influence excercised by Japanese prints in France during this period, evident above all in the photographic approach used.

◆ COUSIN GABRIEL
At the back of the picture the artist has portrayed himself in the company of his cousin, Gabriel, who arrived in Paris in 1891 to continue studying medicine. Like the painter, Gabriel had a passion for the theater and accompanied him in the evenings. With his neck and shoulders bent forward he presents here, as in the picture *Gabriel Tapié de Céleyran in a Theater Corridor* (1893-94, Albi, Musée de Toulouse-Lautrec, below), the characteristic indolent posture representative of the atmosphere of alienation portrayed by Lautrec.

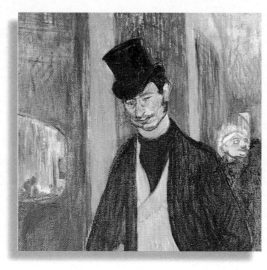

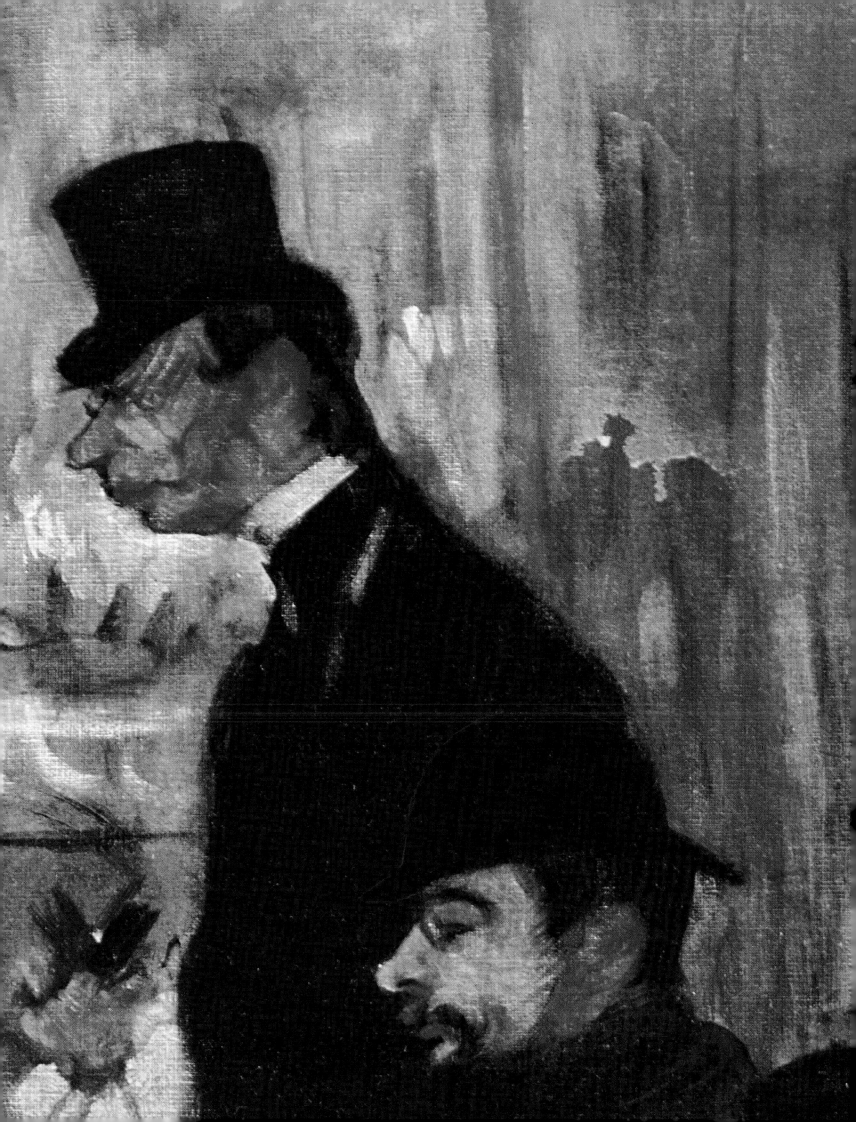

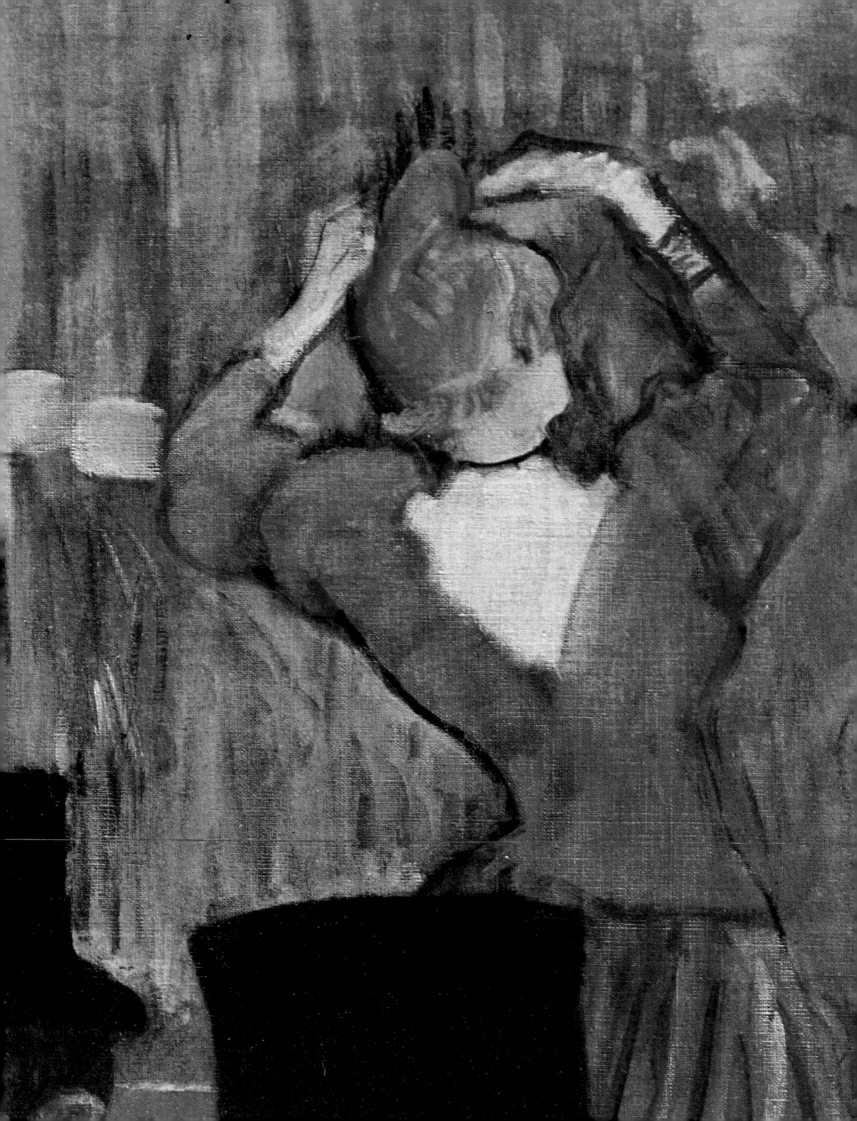

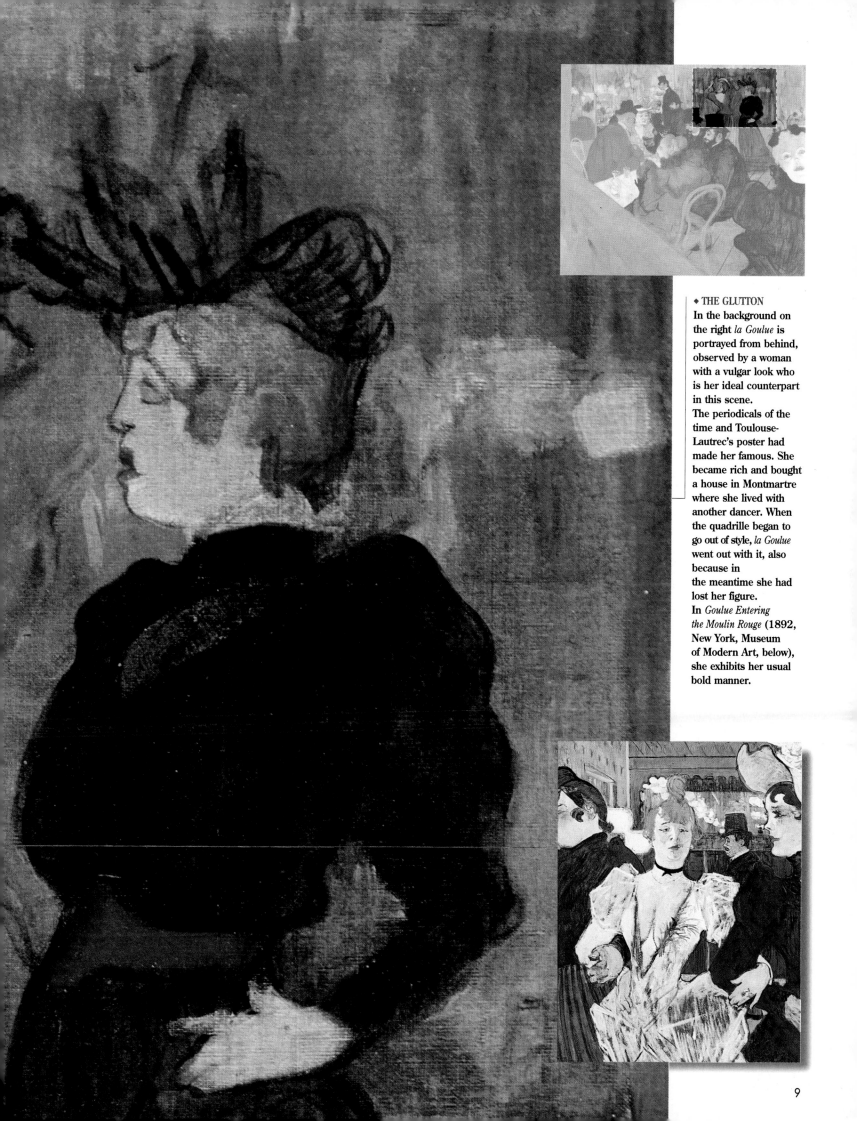

◆ THE GLUTTON
In the background on the right *la Goulue* is portrayed from behind, observed by a woman with a vulgar look who is her ideal counterpart in this scene. The periodicals of the time and Toulouse-Lautrec's poster had made her famous. She became rich and bought a house in Montmartre where she lived with another dancer. When the quadrille began to go out of style, *la Goulue* went out with it, also because in the meantime she had lost her figure. In *Goulue Entering the Moulin Rouge* (1892, New York, Museum of Modern Art, below), she exhibits her usual bold manner.

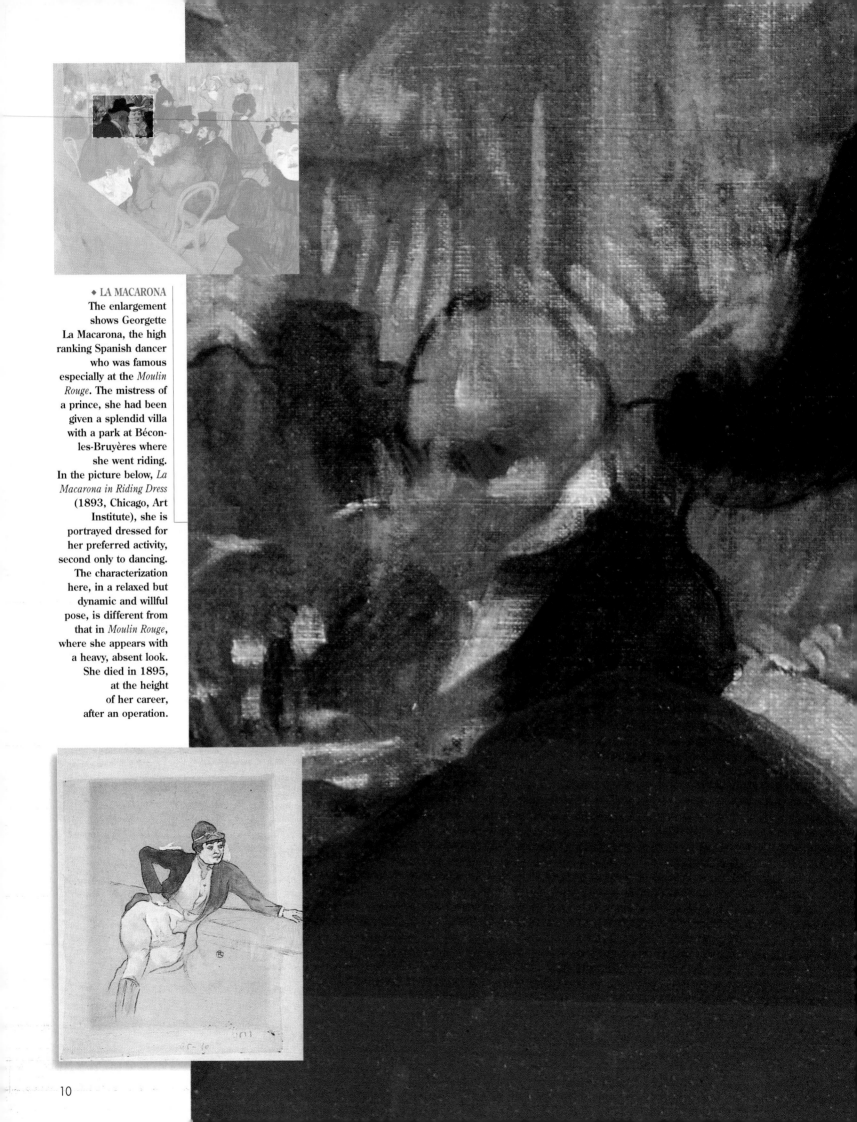

♦ LA MACARONA
The enlargement
shows Georgette
La Macarona, the high
ranking Spanish dancer
who was famous
especially at the *Moulin
Rouge*. The mistress of
a prince, she had been
given a splendid villa
with a park at Bécon-
les-Bruyères where
she went riding.
In the picture below, *La
Macarona in Riding Dress*
(1893, Chicago, Art
Institute), she is
portrayed dressed for
her preferred activity,
second only to dancing.
The characterization
here, in a relaxed but
dynamic and willful
pose, is different from
that in *Moulin Rouge*,
where she appears with
a heavy, absent look.
She died in 1895,
at the height
of her career,
after an operation.

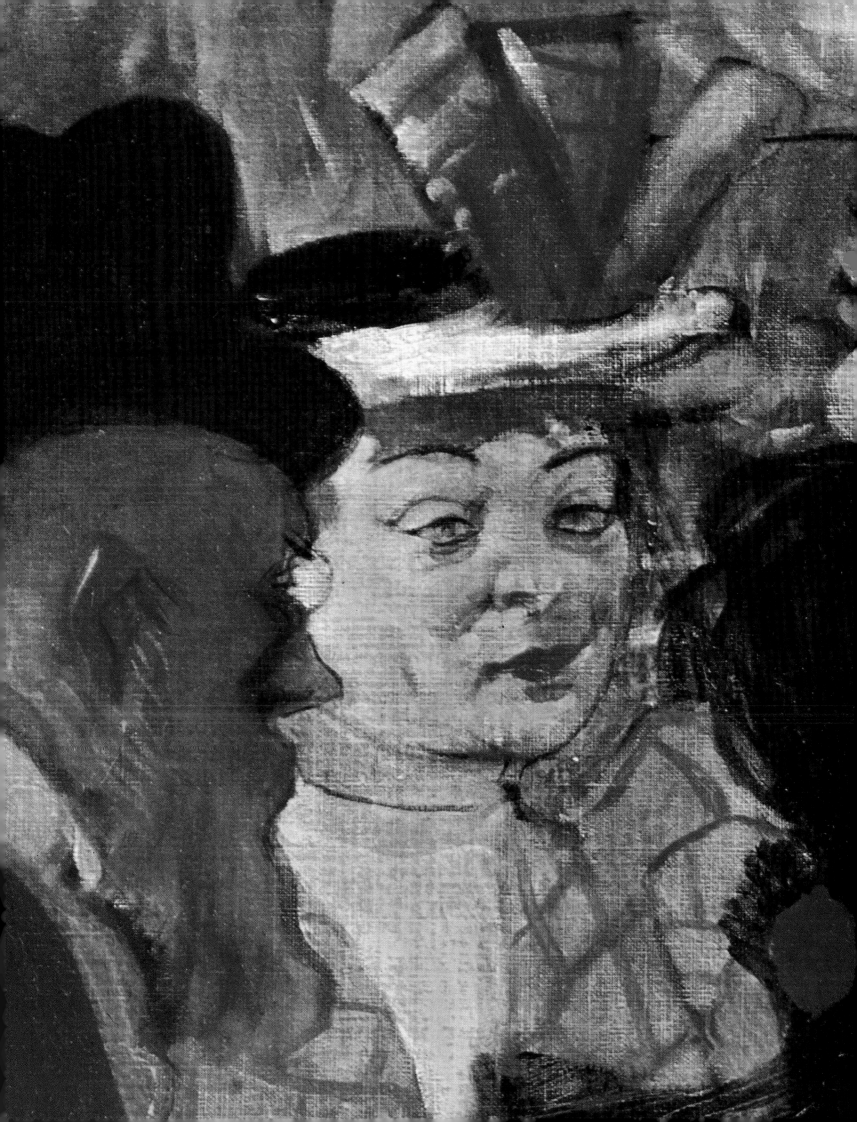

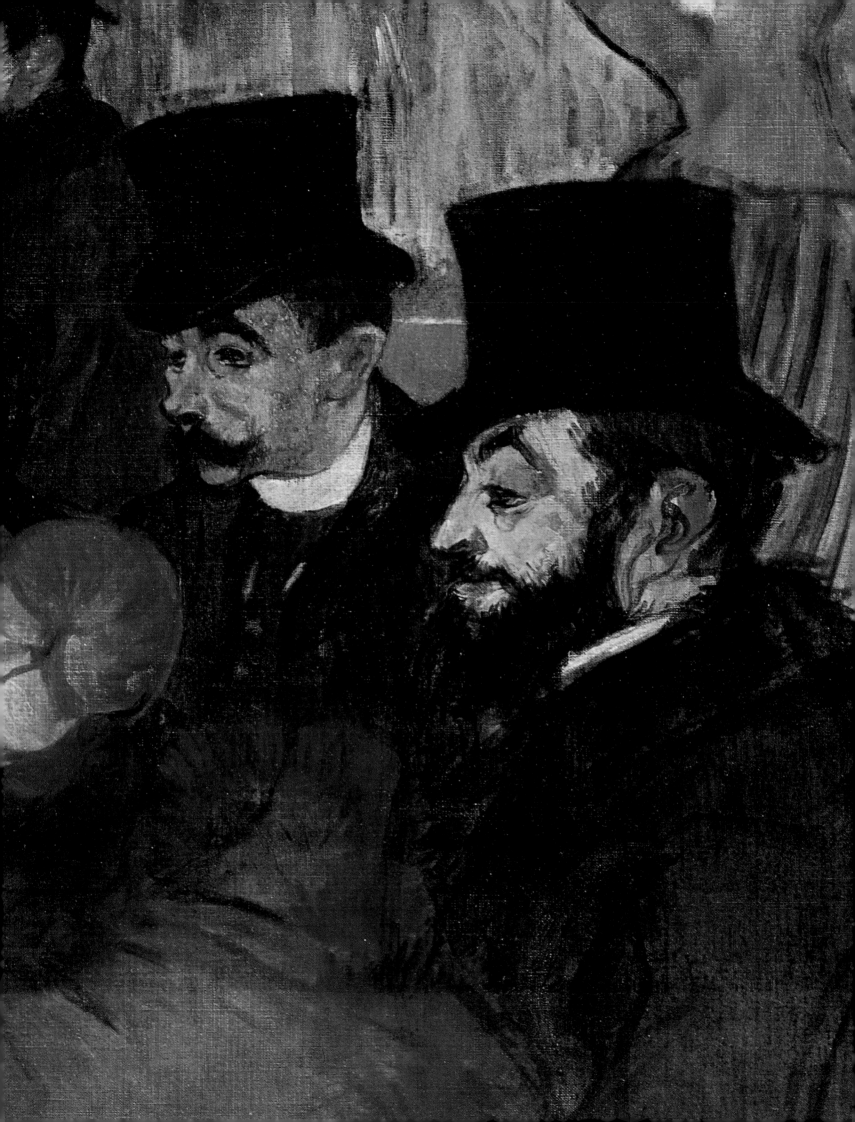

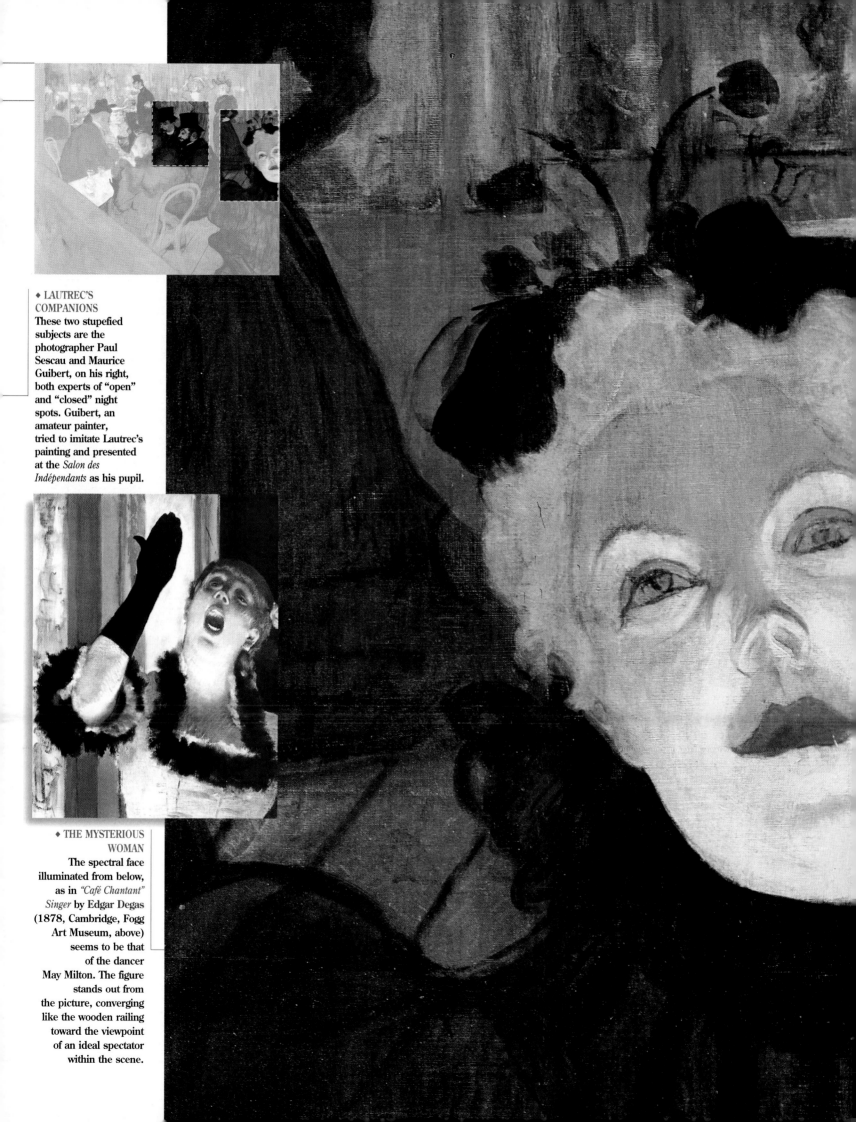

♦ LAUTREC'S
COMPANIONS
These two stupefied
subjects are the
photographer Paul
Sescau and Maurice
Guibert, on his right,
both experts of "open"
and "closed" night
spots. Guibert, an
amateur painter,
tried to imitate Lautrec's
painting and presented
at the *Salon des
Indépendants* as his pupil.

♦ THE MYSTERIOUS
WOMAN
The spectral face
illuminated from below,
as in *"Café Chantant"
Singer* by Edgar Degas
(1878, Cambridge, Fogg
Art Museum, above)
seems to be that
of the dancer
May Milton. The figure
stands out from
the picture, converging
like the wooden railing
toward the viewpoint
of an ideal spectator
within the scene.

A SHOW OF MODERNITY

Some critics maintain that the painting was adapted by Toulouse-Lautrec himself in 1895, with the addition of a large 15 cm strip of canvas on the right edge and about 27 cm on the bottom edge. The latter strip has the painter's signature. The figure of the woman who stands out toward the viewer, lit up from below with an effect that outlines her face, giving it a cold look, has been compared by some to a lighted lantern. This may be the English dancer May Milton, who, according to some critics, the painter added to the painting at a later date. Analysis of the canvas indicates, however, that the painting was done in a single stage, and there are no signs of overlapping paint layers to hide seams. On the other hand, trustworthy credit is given to the affirmation that the painting was cut with the complicity of Maurice Joyant, Toulouse-Lautrec's inseparable friend, a writer and art dealer, after the artist's death.

● The incisive diagonal position of the railing, painted with

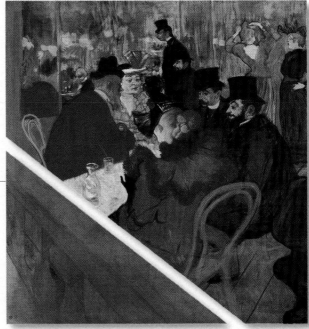

◆ BOLD FORESHORTENING
The picture has a diagonal layout, studied at length in the studio. The white lines trace the division between the layers that Toulouse-Lautrec would add to the picture later. This choice of perspective was not new to painting in that period. Caillebotte and Degas introduced completely new points of view in their paintings based on photography and Japanese art.

fine, rapid strokes, resembles the features of Japanese prints, already popular in France for a few decades before Lautrec did *At the Moulin Rouge*. The bold perspective, animated by decisive oblique lines, invites the viewer to penetrate the picture and make contact with the scene and environment represented, as if one were a client in the room.

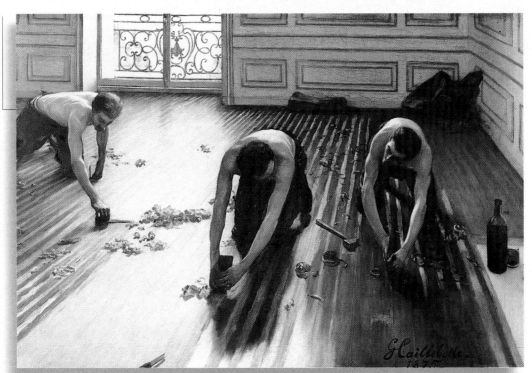

◆ GUSTAVE CAILLEBOTTE
Parquet-Floor Planers
(1875, Paris, Musée d'Orsay).
In his paintings, Caillebotte, patron of the impressionists and a refined painter himself, usually invested pictures with a photographic imprint. Here the view toward the bottom contributes to the uniformity of the room without furniture, together with the rectangular design on the walls, the planks of the wood floor, the gesture of the three similar figures. The railing presents a fine decorative variation, emphasized by the light coming in through the bottom of the window.

◆ EDGAR DEGAS
The Orchestra at the Opéra
(1869, Paris, Musée d'Orsay).
Toulouse-Lautrec took structural suggestions from paintings by Edgar Degas, who, like Caillebotte, arranged the scenes in his pictures using a photographic technique. In this painting Degas focuses attention on the opera orchestra by studying the poses of the musicians, here represented by friends and relatives.

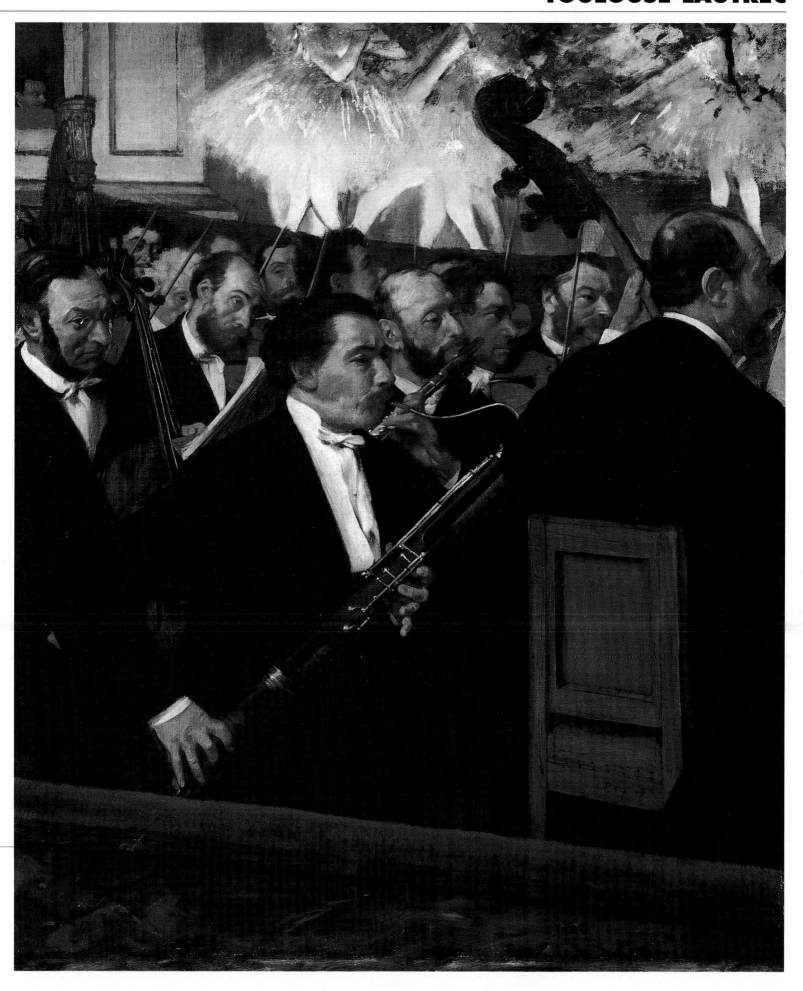

AN ACUTE OBSERVER

enri-Marie de Toulouse-Lautrec-Monfa was born on the night of November 24, 1864 in Albi, in southern France, during a furious storm. His paternal ancestors were the famous counts of Toulouse and the powerful viscounts of Lautrec, and his father, count Alphonse, married his first cousin, countess Adèle Tapié de Céleyran, to assure the union and conservation of the large patrimony of the two families.

● Surrounded by select tutors, Henri grew up thin and delicate, and a fall from a horse when he was 14 left him deformed.

◆ TO MIE [A LA MIE] (1891, Boston, Museum of Fine Arts). This gouache seems to be based on Edgar Degas' *Absinthe* (1876, Paris, Louvre).

A Montmartre model poses with her friend Maurice Guibert while Sescau simultaneously reproduces the scene photographically.

From early childhood he showed a strong gift for drawing, which soon became an imperious need.

● In Paris Toulouse-Lautrec found refuge. The small crippled man did not pass unobserved: he was part of the avant-garde, he knew Emile Bernard, Vincent Van Gogh, Paul Gauguin, and Edgar Degas, and proclaimed himself the painter of daily life, free of pietism and false moralism. An acute observer and recorder of strong realistic scenes, he was close to Symbolism and used an expressionistic, anti-naturalistic range of colors.

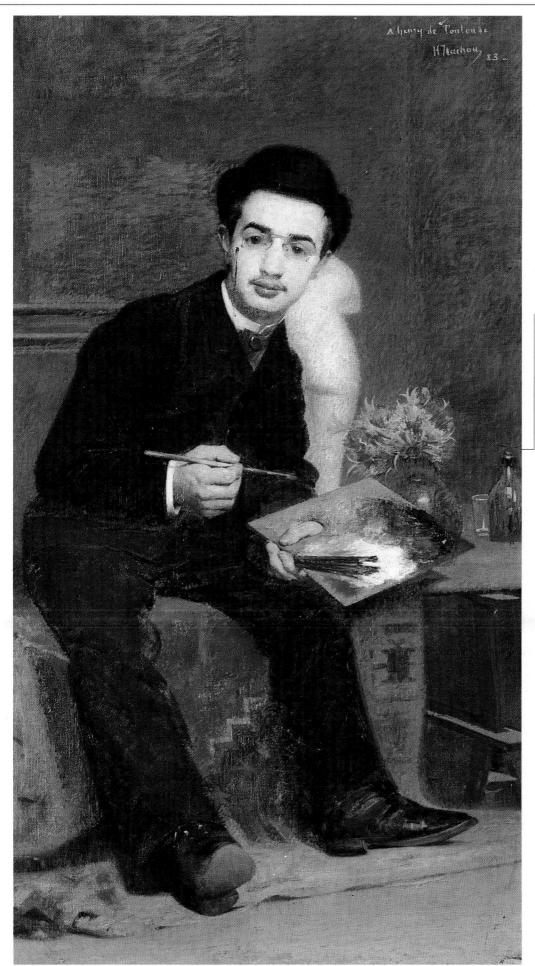

◆ HENRI RACHOU
Toulouse-Lautrec
(1890, Toulouse,
Musée des Augustins).
The young Henri
is portrayed sitting
in his studio, palette
in hand. A splendid
rug from Karamania,
a gift from his father,
covers the sofa.
When Henri decided
to change his
furnishings he gave
this very elegant item
to the painter Gauzi
on the pretext that it
"made the room look
like a bazaar."

◆ IN THE STUDIO
This photo, taken
in 1894, shows Henri
de Toulouse-Lautrec
carefully studying
his painting *At the Salon
de Rue des Moulins*.
Below, the famous
affiche (poster),
*The Passenger
in Cabin 54*, inspired
by a meeting on
a cargo ship taking
the artist to Le Havre;
he was so struck
by the passenger
in cabin 54 that
he continued
on to Lisbon.

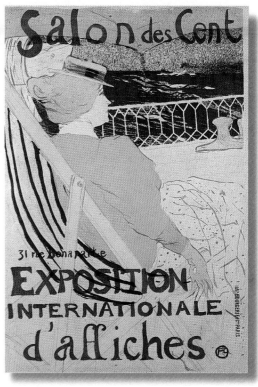

A NERVOUS SCRATCHY STROKE

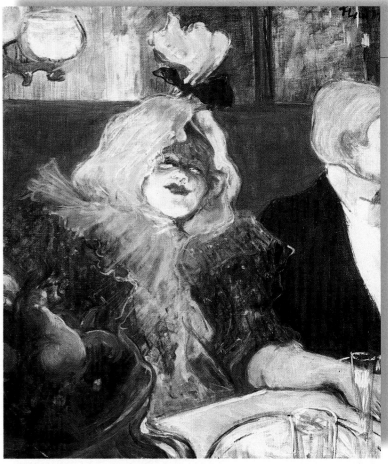

"Your painting isn't bad, there's something there, all told it isn't bad, but your drawing is decidedly atrocious. So you need to take your courage in hand and go ahead and erase." This was the judgment that Henri's first teacher, Léon Bonnat, gave the young artist in 1882. But it was the opinion of an academic painter, one with a precise stroke and oleographic technique. Henri de Toulouse-Lautrec was not interested in recreating optical sensations or truthful light effects; his painting is comprised of lively scratchings, nervous strokes of the brush, that emphasize the essential details of the picture.

● When he portrays the nightlife of the Parisian dance halls and cabarets, using the effects of electric lighting as an instrument in the creative process, his painting is definitely distant from the Impressionistic trend and breaks with the pic-

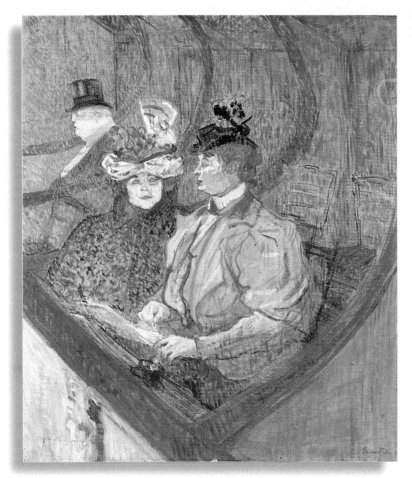

torial tradition of the academy.

● The choice of subjects that attract his brush separate him irremediably from Impressionism, the movement which from the 1870s represents the most modern painting, the bulwark against academic style.

● Toulouse-Lautrec's technique was based on strong colors, with no attention to effects of transparency. His was a relaxed palette: mostly blues and greens, contrasted with purples and pinks, applied with quick, vigorous, loose brushstrokes. In many of his pictures the simplification of tones is compensated by outline-strokes that join light shades with darker ones.

● For large paintings he used canvases, for portraits panels, and for small studies cardboard whose beige color was left unpainted as the background. Lighting effects were done without any objective intention of obtaining a realistic effect.

● The figures are delineated with nervous outlines; the subject is treated with a naturalistic type of realism that did not always correspond faithfully with its physiognomy.

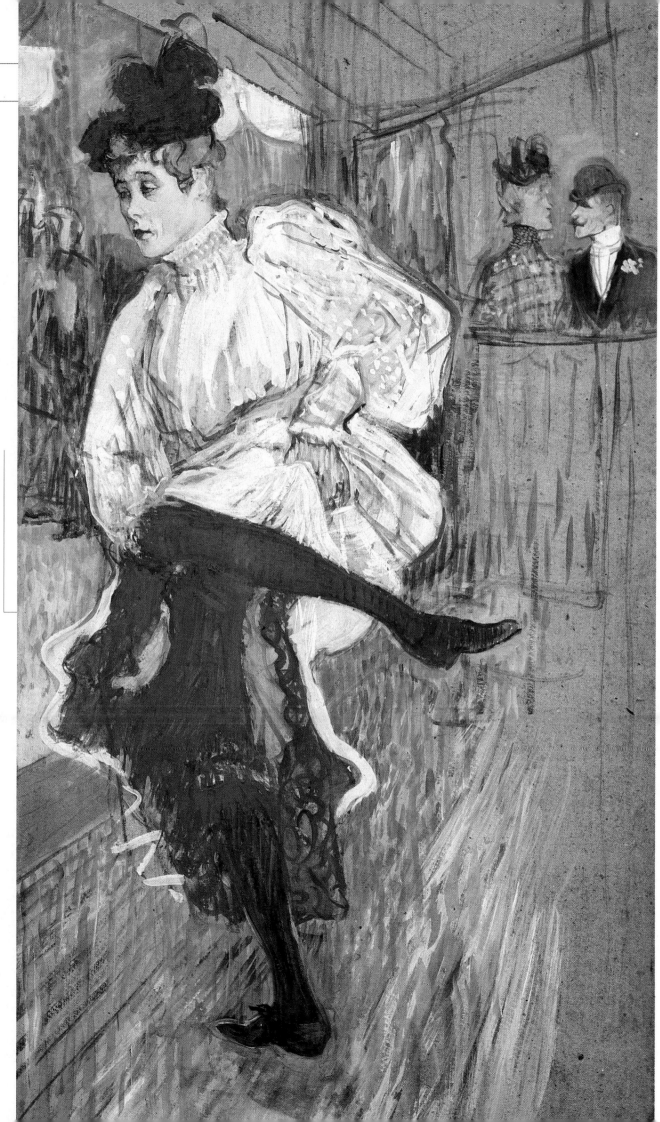

◆ PRIVATE ROOM
AT THE RAT MORT
(1899, London,
Courtauld Institute).
This painting was never
exhibited during
the painter's lifetime
and has remained
anonymous. The *Rat
Mort* was a restaurant
much in fashion, near
Place Pigalle, and
Lautrec went there often
at the end of the 1890s.
The woman is the *demi-
mondaine* Lucy Jourdain,
mistress of the man who
commissioned
the painting. As in other
pictures the painter took
advantage of the lamp
light to lighten the face
of the subject,
with an unrealistic
blinding effect.

◆ JANE AVRIL DANCING
(1892, Paris,
Musée d'Orsay).
Dancer, singer and
actress, daughter of
a *demi-mondaine* who had
died mentally deranged
and an Italian
nobleman, Jane Avril
was the principal
attraction at the *Moulin
Rouge* beginning in
1890. She was the only
Montmartre dancer who
liked Toulouse-Lautrec's
work. The artist gave
her many pictures,
which she regularly left
behind in the houses of
her many lovers. This
picture, playing on cool
tones of color, is
striking because of
the contrast between
the dynamic position
of the dancer
and her sad look.

◆ STUDY FOR
"THE BIG BALCONY"
(1896, private
collection).
In this *gouache*
on cardboard,
a preliminary study for
the lithograph with
the same title, Toulouse-
Lautrec - seen working
in his studio in the oval
at the top of the facing
page - played with
touches of green-blue
color on a red
background. Note
the bold perspective
in this picture.

THE EARLY WORKS

During childhood Henri de Toulouse-Lautrec spent most of his time drawing, following in the steps of his great-grandfather Raymond – a portrait artist of the neoclassical school – and his father Alphonse and uncle Charles who were amateur painters.

● His vocation, according to his own account, dated from 1868, at age four, when at the baptism of his cousin Raoul Tapié de Céleyran, he drew an ox in the ceremonial signature book because he couldn't yet write his name.

● His first oil paintings, done when he was fourteen, deal with themes such as family life, hunting, the nobility, and horse-drawn carriages.

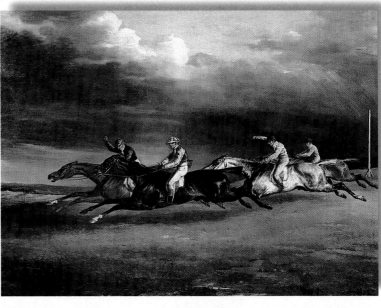

◆ THÉODORE GÉRICAULT
Horse Race at Epsom
(1821, Paris, Louvre) Toulouse-Lautrec's passion for the subject of galloping horses was based on the works of the great French romantic painter Géricault.

◆ FERNAND CORMON
Cain Fleeing with His Family
(1880, Paris, Musée d'Orsay). Officially recognized and appreciated by the *Salon* critics, Cormon had an excellent technique. His influence on Toulouse-Lautrec is evident in Lautrec's works up until about 1885. Cormon's figures are anatomically perfect and his paintings show great attention to detail.

◆ SELF-PORTRAIT AT SIXTEEN
(1882-83, Albi, Musée Toulouse-Lautrec). Toulouse-Lautrec did very few self-portraits. In addition to this there is one other in which, very ironically, he portrays himself from behind in front of his easel. In the painting reproduced here, the artist is wondering about his own identity, describing himself beyond the bounds of habitual conventions of genre painting. He is detached, appearing isolated and objective, while spot lighting brings out the eyes and mouth. Resemblance has become a secondary aspect. This work shows none of Gustave Courbet's narcissism nor Vincent Van Gogh's pathetic search for himself.

● On April 17, 1882 he entered the Paris *atelier* of Léon Bonnat, considered a capable historical artist and portrait painter, an expert on Rembrandt (1606-1669) and Ribera (1591-1652), and a good teacher. After only three months of study the young pupil left Bonnat to study under Fernand Cormon, an already affirmed but more eccentric artist, who liked prehistoric subjects. The new studio was in the Parisian quarter of Montmartre. Henri thus began to frequent this area and became interested in the urban lower classes, and he experienced the influence of the realistic painters Raffaëlli, Forain (1852-1931) and Degas, then the major participants in the Impressionist exhibitions in rue Le Pelletier in Paris.

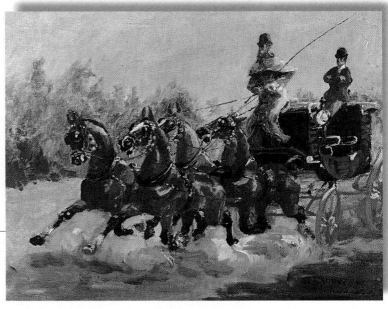

◆ ALPHONSE DE TOULOUSE-LAUTREC DRIVING HIS CARRIAGE
(1880, Paris, Musée du Petit Palais). The forward thrust of horses is one of the fundamental themes in Toulouse-Lautrec's early works.

"ONLY THE FACE EXISTS"

L autrec painted his portraits using all the variations possible in the genre: full figures, half length, still or in movement, inside a room or in a landscape, or even immortalized against an abstract background.

● According to his aesthetic convictions, expression was more important than the person. He himself said to his friend Joyant, "only the face exists." His artistic ambition was to reveal the peculiarity of each human being, overcoming the stereotypical image of appearance to arrive at extrapolating the personality of his models.

● In the meticulous choice of accessories, clothing, furnishings, not to be interpreted as a realistic requirement, Toulouse-Lautrec tried to express the intimate nature of his personages. Bizarre, excessive and extravagant, the artist sometimes fo-

◆ CARMEN (1884, Williamstown, Sterling and Francine Clark Institute). Carmen Gaudin was a working class girl whom he met in the street in Montmartre. Toulouse-Lautrec was struck by her copper-colored hair, and wanted absolutely to portray it.

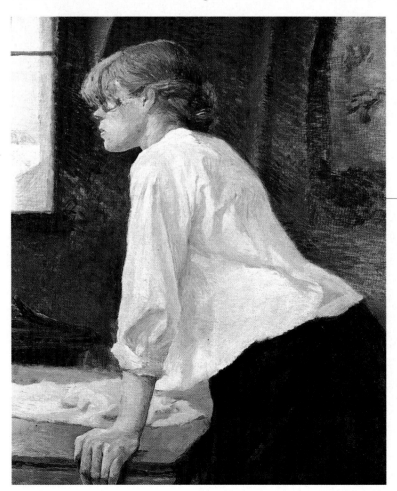

◆ WASHERWOMAN (1889, Paris, private collection). Again the model is Carmen Gaudin, painted by Lautrec many times in this period. The artist shows here that he had assimilated Cormon's and Bonnat's lessons, although he is moving towards a language of his own.

cused his imagination on a small detail that became the protagonist of the picture. Thus he would abandon a portrait only halfway through because a yellow vest that the model had been wearing had disappeared, or he would accept to do a portrait of Louis de Lasalle only on the condition that the subject cut his mustache.

● His cousin Gabriel Tapié de Céleyran recounted that when a physiognomy struck Toulouse-Lautrec's fancy he would, with no concern about who the person was, say: "You would do me a great service if you came to my studio to pose for a portrait. It probably won't look much like you at the end, but that is not at all important."

◆ PAUL LECLERCQ (1897, Paris, Musée d'Orsay). A young, high ranking man of the world, the Belgian writer Paul Leclercq, greatly esteemed by Toulouse-Lautrec, was one of the founders of the *Revue Blanche.*

◆ JUSTINE DIEUHL
SITTING IN
THE FOREST GARDEN
(1889, Paris,
Musée d'Orsay).
Portrayed sitting full-
front, somewhat rigid
and apathetic, Justine
appears to be sitting on
a not-very-stable folding
chair that makes her
position awkward and
clumsy. Beginning at
the irises, the blue of
her eyes extends to
the corneas, giving her
a naive look.
The painting was
the property of the
Japanese prince
Matsukata until 1959
when it was donated
to the Louvre.

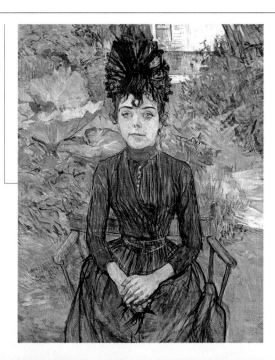

◆ OSCAR WILDE
(1895, private
collection).
Tried and imprisoned
in 1895 for
homosexuality, Oscar
Wilde became Toulouse-
Lautrec's prototype of
the martyr-artist.
According to some,
the writer refused to
pose for Henri, who, in
order to do the portrait,
went to all the sittings
of the trial and then
reproduced this insolent
image in his studio.
In the background one
can recognize a vague
suggestion
of the countryside
along the Thames
near London.

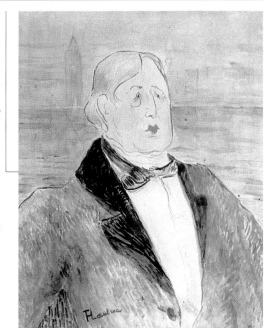

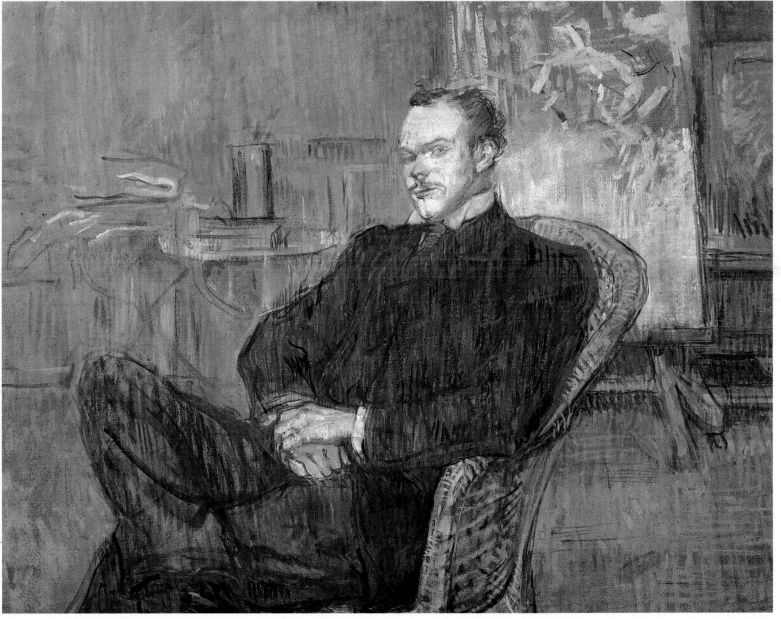

PARIS BY NIGHT

For Henri de Toulouse-Lautrec, Montmartre represented a fascinating mystery, a vast domain that he explored every night. From Place Pigalle to Place Clichy, as far as the *Moulin de la Galette*, the cabarets, *café-dansants*, and the public dance-halls were places of amusement and work for him. He became a legendary figure in this quarter of Paris. Attentive, always brush in hand and his nose over the rim of a glass, he watched the night life, absorbing sensations and behaviors.

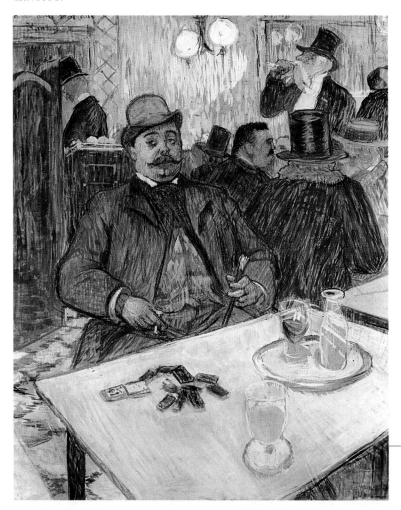

● The popular visual language used by Toulouse-Lautrec, far from ideological, belongs to a late nineteenth century artistic trend recording the attenuation of the distance between different social classes. The images of the pleasures of Montmartre present the viewer with the problems of a modern city, transformed in only a few decades from the Third Republic with Baron Haussmann's urban planning, but still dominated by exploitation and alienation.

◆ VALENTIN-LE-DÉSOSSÉ TRAINING THE NEW GIRLS (1889-90, Philadelphia, Museum of Art). Here there are 26 figures, with those in the foreground life-size compared to the viewer; this is one of Toulouse-Lautrec's most ambitious paintings. After being exhibited at the *Salon des Indépendants*, the painting was hung over the bar in the *foyer* of the *Moulin Rouge*. In the center the artist's friends Paul Sescau and Maurice Guibert watch a lively quadrille.

◆ MONSIEUR BOILEAU (1893, Cleveland, Museum of Art). Monsieur Boileau's true identity is unknown. He is supposed to have been a businessman whom Lautrec met in a café and with whom he became great friends. This is one of the artist's most meticulously painted portraits; it shows great attention to detail. Note the way the man's hand grasps, almost in a Baroque manner, the walking stick and his masterful look. The man with the white beard in the background, on the right, is the artist's father.

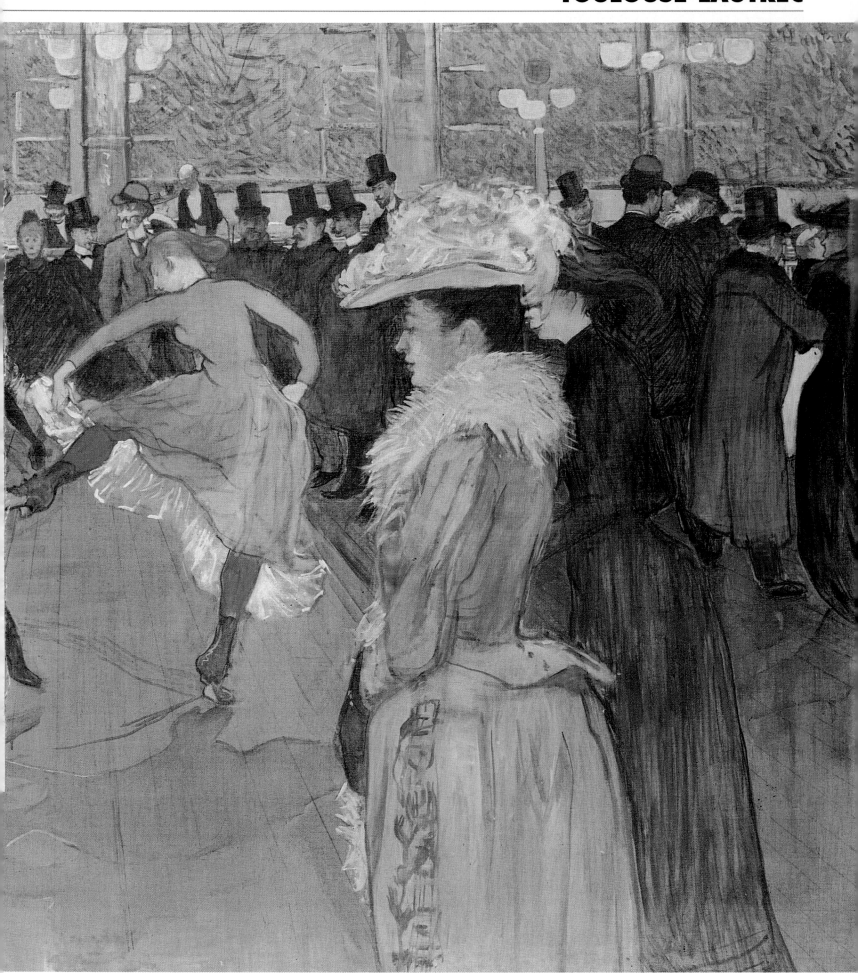

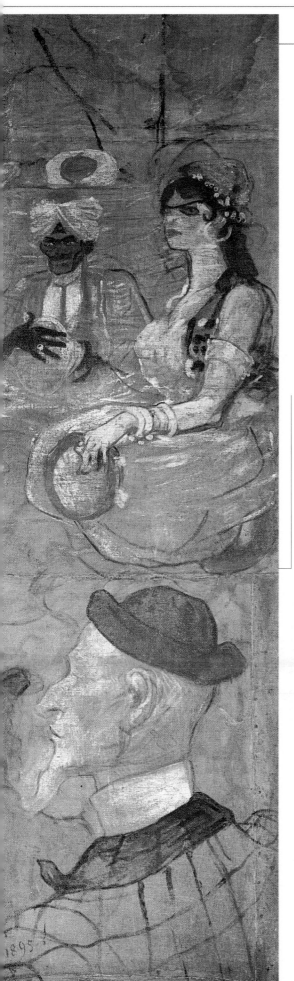

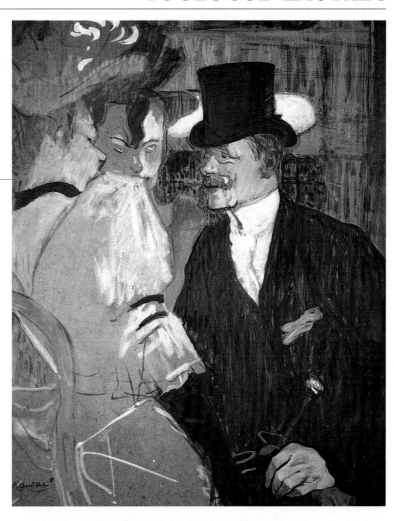

◆ STUDY FOR "AN ENGLISHMAN AT THE MOULIN ROUGE" (1892, New York, Metropolitan Museum). The model for the male figure is the Englishman William Warener, Justice of the Peace in Lincoln and son of a coal merchant. In about 1891 he became part of William Rothenstein's and Charles Conder's circle in Paris, both great friends of Toulouse-Lautrec. The artist valued Warener as a subject precisely for his characteristic English air with his mustache and top hat.

◆ MOORISH DANCE (1895, Paris, Musée d'Orsay). In this oil on canvas, Toulouse-Lautrec portrays the performance of *Goulue* with her tent at the *Moulin Rouge*. The bellydance, made popular thanks to the shows in the Moroccan and Egyptian pavilions at the Universal Exposition in Paris, was a great hit with the audience. One can recognize, seen from behind, left to right, Tapié de Céleyran, Oscar Wilde, and the literary figure Félix Fénéon.

◆ THE WHEEL (1893, São Paulo, Museu de Arte). The luminous outline of the dancer, shaded with acid green and purple, contrasts with the dark male audience. Toulouse-Lautrec places the viewer behind the scenes, like an actor in this grand nighttime show waiting for his entrance cue, his turn on stage.

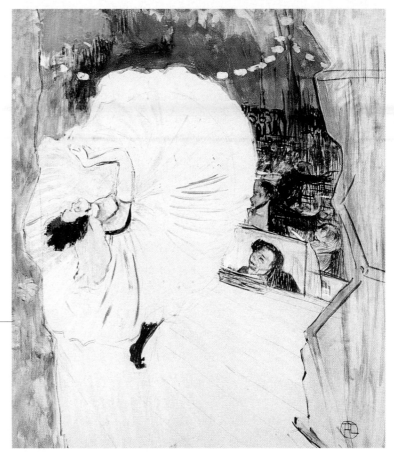

THE STARS AND STARLETS

Henri de Toulouse-Lautrec's production is closely related to Parisian worldly life and, coinciding with the height of the *café dansant* era, it deals with the world of the stars at the end of the century. The glories of Yvette Guilbert, Aristide Bruant, and Jane Avril were mostly recorded by the little artist's incisive pencil, which portrayed them in action on stage or in poster presentations of the shows. The master's work documented their triumphs step by step.

● Aristide Bruant, bound to Toulouse-Lautrec by a long friendship, was a modest railroad employee who became a famous popular singer and then opened his own cabaret, *Le Mirliton*, at 84 Boulevard Rochechouart.

● Ethereal, good looking, refined and elegant, yet gifted with devilish energy, and with the nickname *"La Mélinite"* (a substance similar to dynamite), Jane Avril was considered the incarnation of dance. She lived surrounded by a crowded court of admirers, of whom Toulouse-Lautrec was the most constant.

● An American from Illinois, Loïe Fuller was the "butterfly" of Paris. With a specialized team of electricians she perfected a show based on the use of hand-held sticks to twirl veils around her body while standing with her legs still.

● Authorized since 1867, the shows with these dancers and singers were accused of competing with the theater. Actually they were directed toward a popular public, offering low-priced amusement. Despite censure, these shows were the norm in places that allowed freedom of expression.

◆ ARISTIDE BRUANT (1851-1925). Composer and song-writer, he created his own genre of very realistic, often anarchical songs with lewd quips addressed to the audience.

◆ JANE AVRIL (1868-1943). Dancer, singer and actress, Jane Avril did frenetic dances in the fashionable Parisian nightclubs. Later she was also highly successful in London.

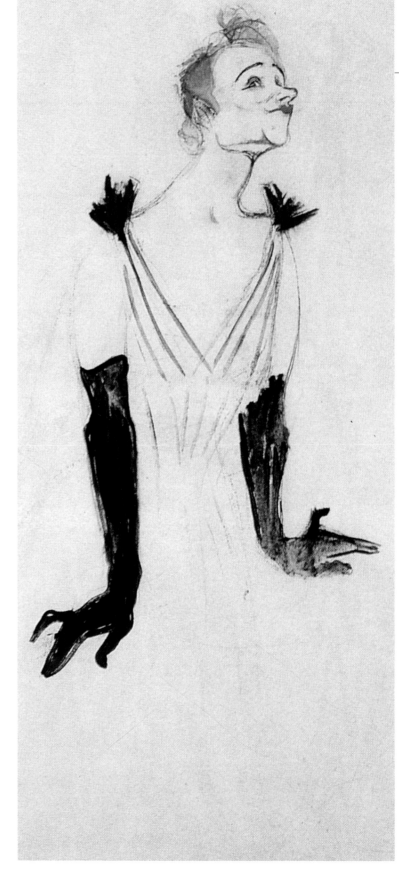

◆ YVETTE GUILBERT
(1894, Albi, Musée
Toulouse-Lautrec).
This charcoal
drawing was
a study for a never
realized poster.
The project was
refused by Guilbert
who saw herself
portrayed as
very ugly. In a letter
to the artist about
the portrait she wrote:
"For heaven's sake,
don't make me so
atrociously ugly!
Many people who
come to visit haven't
been able to withhold
terrible cries
upon seeing it."

◆ STUDY OF LOÏE
FULLER
(1893, Albi, Musée
Toulouse-Lautrec).
This famous
study shows Loïe
Fuller's overwhelming
dance shows,
which Edmond
de Goncourt loved
to define as
"a hurricane
of materials
and vortex of skirts."
The dancer's
dress is an agitated
spiraling whirl
that seems to transport
her body upward.
The quickness
of execution
is evident.

◆ YVETTE GUILBERT
GREETING
THE AUDIENCE
(1894, Albi, Musée
Toulouse-Lautrec).
The picture was done
from an enlarged
photograph in the star's
album. This technique
makes the painting
unique and documents
the rich relationship
between painting
and photography
at the end
of the nineteenth
century. Her thin body,
thin lips, black gloves,
and bat-like air,
made this starlet
famous in the *fin-de-
siècle* Parisian night
spots. At the time she
was 27 years old, but
Toulouse-Lautrec
portrays her as much
older and less graceful
than she was. She
began as a fashion
model, then became
a saleslady
at the Parisian
department store
Printemps. In 1886
she made her stage
debut at the *Eldorado*,
and became famous
reciting monologues
by Maurice Donnay
in 1891-1892.

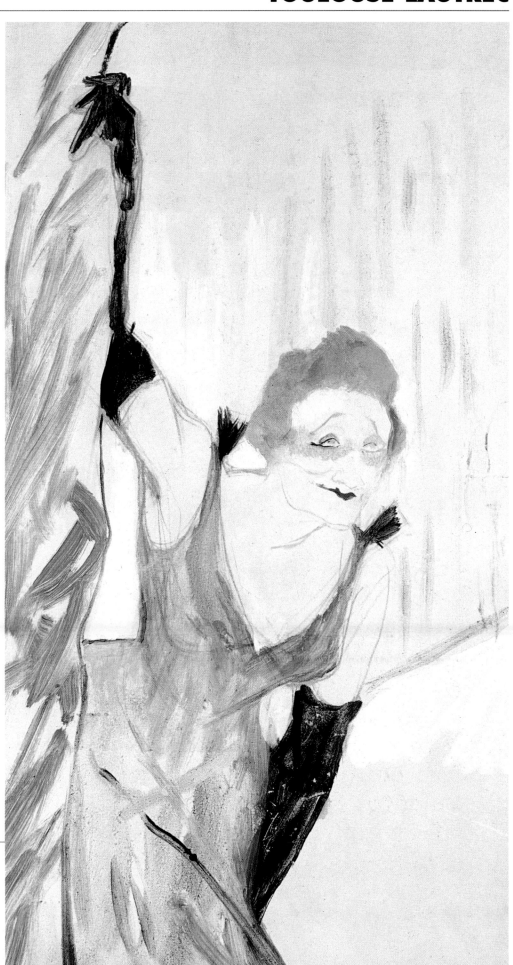

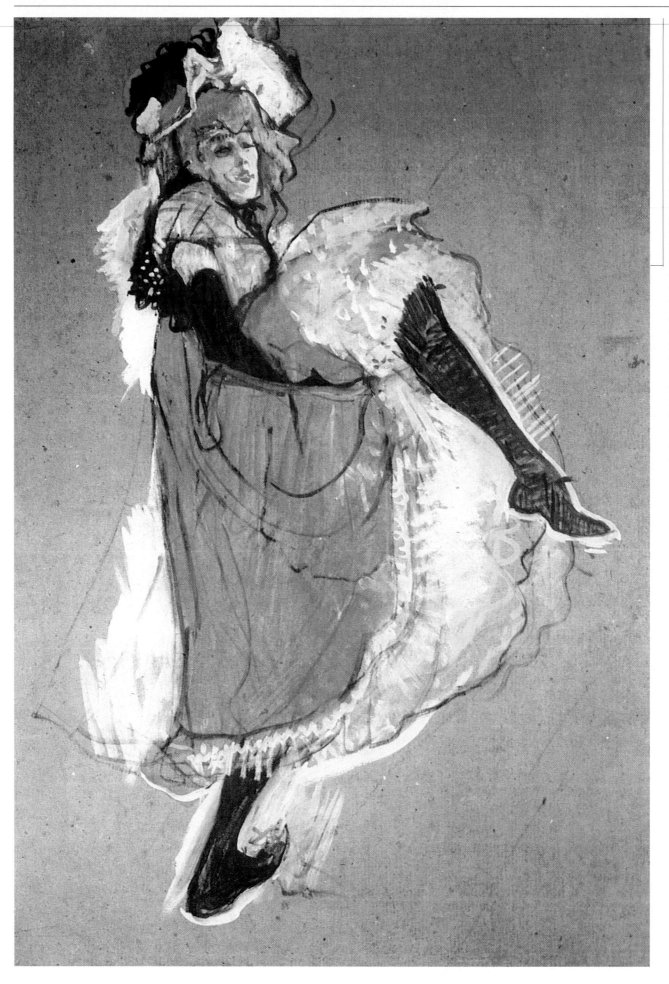

◆ STUDY OF "JANE AVRIL" (1893, private collection). The full white muslin skirt, high neck, and puffed sleeves characterize the figure of Jane Avril, the dancer. The artist did this oil on cardboard picture probably from a photograph (shown in the oval at the bottom of page 28) because a model could not have held the position for very long. But, Toulouse-Lautrec altered the facial expression: the dancer is no longer smiling with the lively, uninhibited air she has in the photograph. Instead, here the painter has evidenced the intense muscular strength that contracts her features.

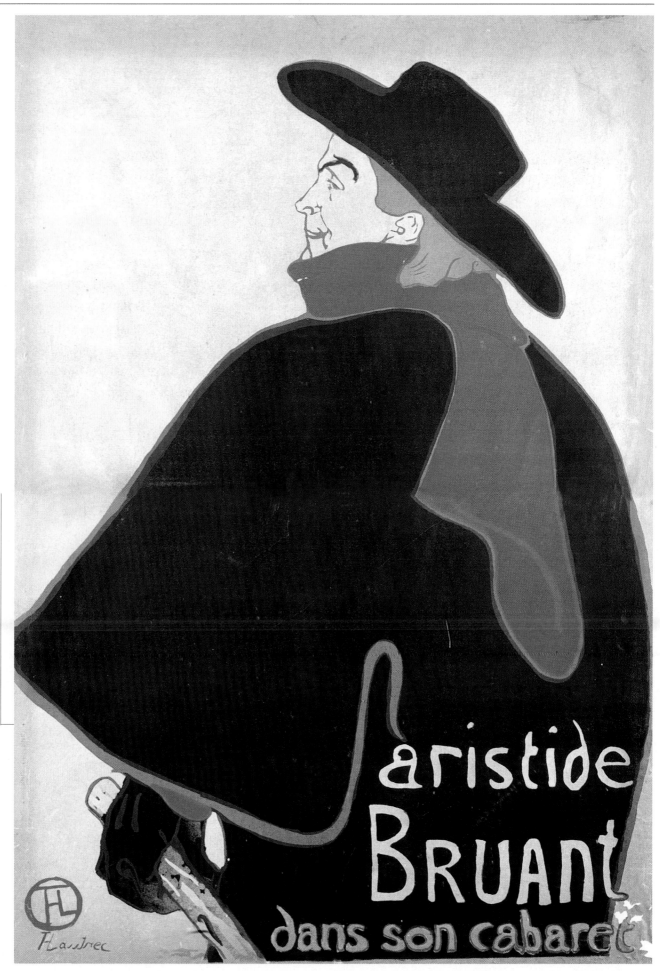

◆ LYRICAL ALCAZAR: ARISTIDE BRUANT (1893, Paris, Musée de Montmartre). Printed by Ancourt, this is Toulouse-Lautrec's fifth poster for Aristide Bruant. The artist shows a rear view of the singer's imposing figure, head in profile, allowing a glimpse of his expression, with his features reduced to the bare minimum. Such a modern pose for a publicity poster was possible only because Bruant had already reached full celebrity. A copy of the *affiche* was chosen for inclusion in the art poster exhibition at the 1896 *Cirque de Reims*, thus decreeing Toulouse-Lautrec's indisputable fame as a poster artist.

SPANGLES AND SEQUINS

When a boy, Henri de Toulouse-Lautrec was taken to the *Circo Fernando* in rue des Martyres and was struck by the fantasy of the show, the ability of the acrobats, the ferocity of the wild animals, and the comicality of the clowns. His first representations of this popular subject, done between 1886 and 1887, were probably based on this experience and belong to a transitional period in his work. Fans, drums, elegant but frivolous decorations became the protagonists in his paintings, and the artist portrayed the shows produced for the masses, contrasting them to the hypocritical high-brow aristocratic theaters in the city center.

● At the enormous *Hippodrome* in Avenue d'Alma, with the presentation of pantomimes and carriage races, the *Cirque d'Eté*, open from May to October at the end of the Champs-Elysées, the *Nouveau Cirque* in rue Saint-Honoré, or the very popular *Cirque Molier* near the Bois de Boulogne, Toulouse-Lautrec studied the enthusiastic audiences and characteristic stage personages for evenings on end, accurately capturing their poses and expressions as well as the vivid colors.

● The most famous show of the time was the *Circo Fernando*, which settled in Paris in 1873. The owner, Ferdinand Beert, an acrobat on horseback, had transformed his original tent of wood and canvas into a permanent structure. The favorite part of the show was Madrano the Clown.

♦ HORSEBACK RIDER AT THE CIRCO FERNANDO
(1887-88, Chicago, Art Institute).
The artist did this painting very quickly, and no preceding sketches exist.
The almost careless style is intentional.

♦ EDGAR DEGAS
Mademoiselle Lala at the Circo Fernando
(1879, private collection, detail).
In Paris the circus was a very popular event.
Even Degas was fascinated by it.
In the oval is an acrobat as portrayed by the artist.

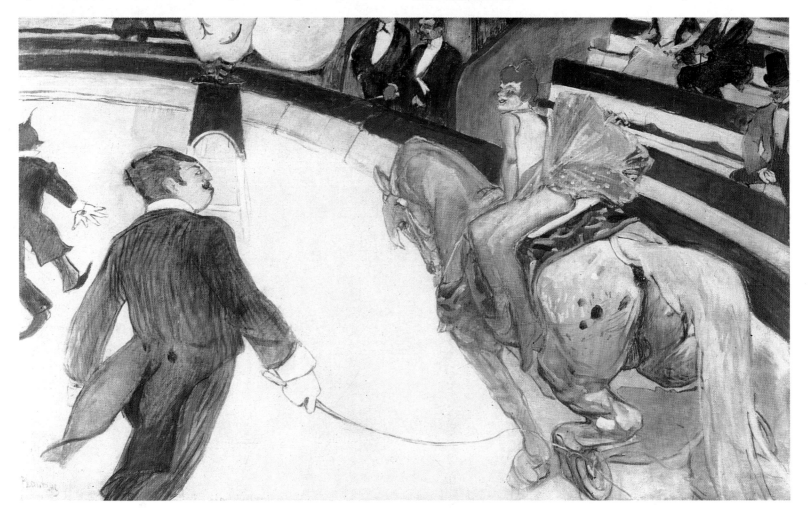

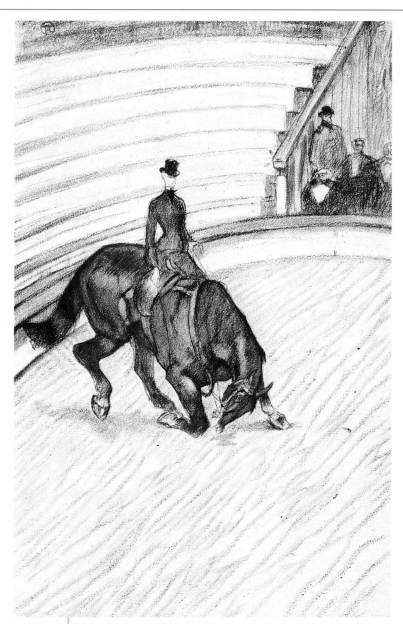

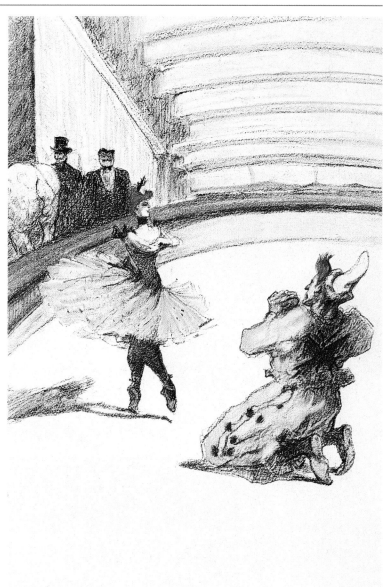

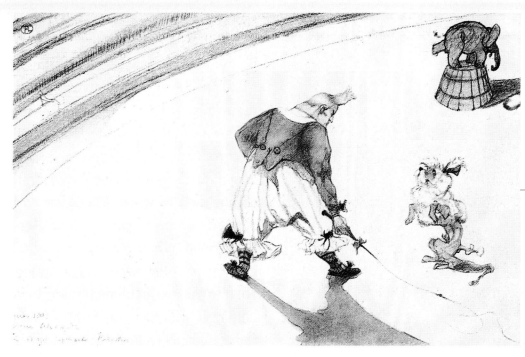

◆ EXPERT RIDER
(1899, private collection).
At the end of their act the rider and his horse salute the audience. This drawing of a circus dates to the period when the artist was in Dr. Sémelaigne's clinic in the spring of 1899. To certify his mental health and evade the suffocating atmosphere of the clinic Toulouse-Lautrec felt the need to do drawings of subjects beloved in his childhood.

◆ AT THE CIRCUS: FOOTIT, THE TRAINER-CLOWN
(1899, Copenhagen, Statens Museum for Kunst).
The drawing on the left has a note in pencil: "Madrid, Easter 1899, to Arsène Alexandre, in memory of my imprisonment." Dr. Sémelaigne's clinic was in rue Madrid in Neuilly and Lautrec was there from the end of February to early March. Above, another drawing from the same series, *The Clown and the Dancer* (1897, Albi, Musée Toulouse-Lautrec).

DECADENT LOVE

Perhaps Toulouse-Lautrec's most famous paintings are those depicting brothels (*maisons closes*). Their fame was enhanced by the scandal press of the era, which continually criticized the artist, accusing him of immorality. Accepted readily by the closed community of the brothels, Henri de Toulouse-Lautrec evidenced its domestic character, neglecting the erotic aspect and excluding the male clientele from his portrayals. His scenes mostly illustrated the tedium of slack days, of inactivity. He shows girls making beds, chatting around a table, or on couches or playing cards. In the exclusively feminine world of the brothels the little artist found in the prostitutes, who welcomed him with ease, a surrogate family.

● The painter worked in many brothels in the center of Paris, especially in the area around the Opéra and the Bib-

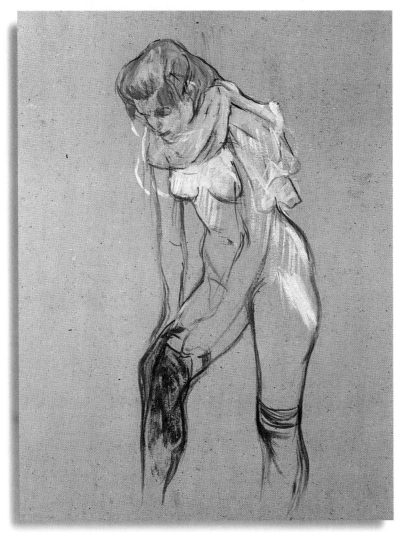

liothèque Nationale, at 3 rue d'Amboise and 6 rue des Moulins. He did life sketches and then finished the pictures in his studio.

● Based on the precedents established by Gustave Courbet, all through the 1890s Toulouse-Lautrec devoted himself to Sapphic scenes, exploring for the first time in the history of art the psychological side of female homosexual relationships. The women portrayed are the object of the artist's voyeuristic interest; he presents the scenes to the indiscreet eyes of the viewers. This attitude is in keeping with Lautrec's choice of treating subjects from the decadent subculture in which he was formed, and he was influenced by the increasing iconography of lesbians in Decadent art.

♦ AT THE SALON
IN RUE DES MOULINS
(1894, Albi, Musée
Toulouse-Lautrec).
An important example
of the brothel
theme, this large
painting involved
very careful
preparation:
the artist
did numerous
preparatory drawings.

♦ MEDICAL
EXAMINATION
(1894, Paris,
Musée d'Orsay).
Here on the left an oil
painting done from
a life model, Gabrielle,
representing one
of the most debated
topics involving
prostitution at the time:
medical examination.
The liberals considered
it ineffective,
maintaining that
the poor sanitary
conditions under which
it was done contributed
to the spread
of infection.

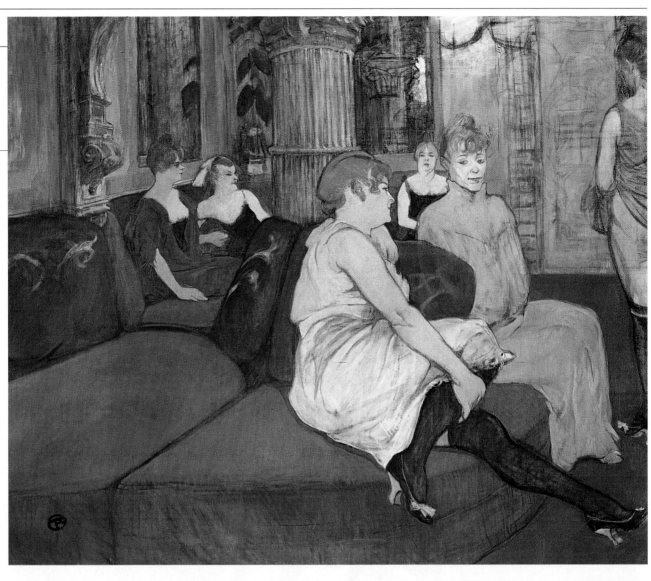

♦ TWO FRIENDS
(1895,
private collection).
The light,
the soft touch,
the gestures of
intimacy, give this
picture an apparent
spontaneity.
It is the best of
the four paintings
of lesbian couples
that Toulouse-Lautrec
did in the mid-1890s.

♦ STUDY FOR
"WOMAN PUTTING
ON STOCKINGS"
Evidently done
from life, this oil
painting is part
of a series
of three partly
caricature scenes
involving brothels.
The rendering of the
anatomy shows
evidence of Cormon's
teaching.

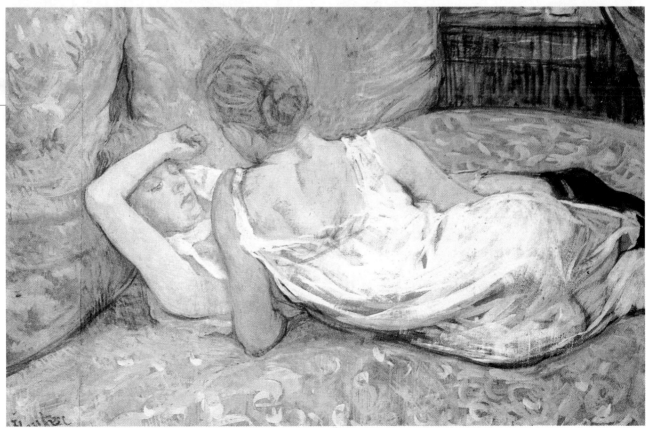

THE MASTER OF SHOW-BILLS

Toulouse-Lautrec's great graphic production is comprised of posters. In the years between 1890 and 1900 he became a master of show-bills: he drew the publicity posters put up outside the nightspots, the theaters, in the streets, and he invented a manner of expression that was exploited universally.

● His lithographs are perfect interpretations of Symbolistic theater, the world of popular songs, and the worn art of choreography. Everything he painted was seductive; the language of his posters was direct and essential and

◆ JANE AVRIL AT THE JARDIN DE PARIS (1893, London, British Museum). This is one of the most famous posters done by Toulouse-Lautrec, commissioned by the cabaret *Le Jardin de Paris* at the request of the starlet, his friend.

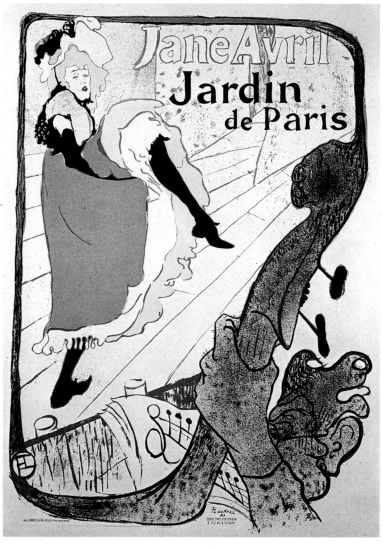

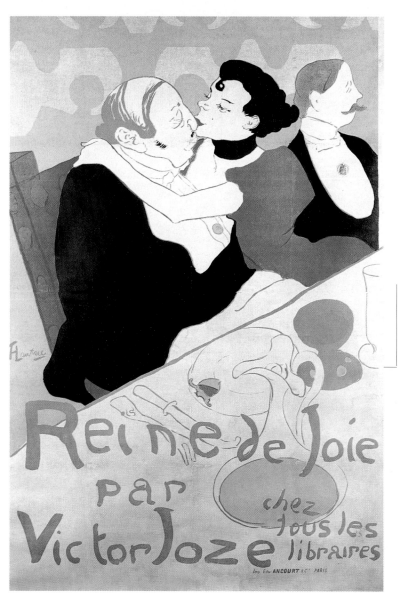

◆ QUEEN OF JOY (1892, Paris, Musée de l'Affiche et de la Publicité). This poster advertises a novel in the series *Ménagerie sociale* representing venal love between the heroine and a banker.

took advantage of his great mastery of drawing.

● This stage of his work developed simultaneously with the birth and spectacular diffusion of Art Nouveau. In the wake of the Arts and Crafts movement of William Morris and John Ruskin, who affirmed the unity of art in all its creative forms in England in the 1860s, the decorative arts became an aesthetic manifestation of primary importance. During one of his trips to Brussels Toulouse-Lautrec met Henri Van de Velde, the head of the Art Nouveau school.

◆ MOULIN ROUGE - LA GOULUE (1891, London, Victoria and Albert Museum). This poster for Goulue's show at the *Moulin Rouge* was printed by Charles Levy.

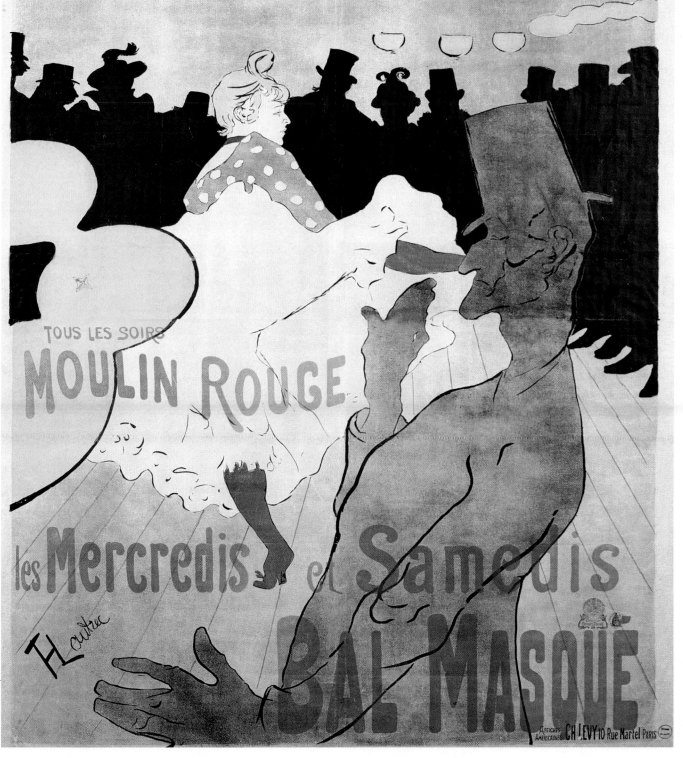

A PARABLE OF DEATH

In his late works Henri de Toulouse-Lautrec often used dark shades and a heavy, pasty application of paint. Attacked by contemporary critics, who blackballed his works depicting modern city life, the artist turned to the past, the old masters, Rembrandt and Goya, considering this stage of his work an opening to new experimentation, further pictorial development. Even the subjects belonged to his rich heritage of memories: he returned to painting horses, circuses, and also historical subjects. His studies of light had never been so bold.

● In a dramatic self-destructive path, the artist found in excess a pleasant way of suicide. He became an alcoholic and worked feverishly. He himself recounted that alcohol was one of the tragedies of his life. He got drunk for the first time in

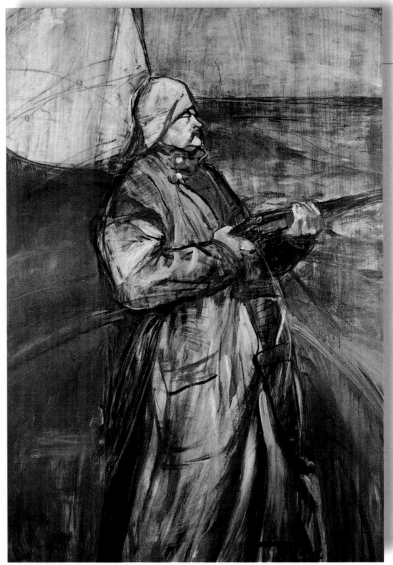

1881 and little by little made himself a real reputation of being a lover of the bottle. "He didn't drink to forget his misfortune, although drinking he did forget it," a friend wrote. Alcoholism and the great amount of work aggravated the problems of his congenital disease.

● In his latter years he resurrected works that had been entirely abandoned for new projects and finished them. He put his monogram on the paintings he thought best. "I want to paint until I'm 40," he said, "but from 40 on I want to be empty." However, at barely 37, in mid-August 1901, Henri de Toulouse-Lautrec became paralyzed and died only three weeks later. He was buried first at Saint-André-du-Bois, and then moved to Verdelais, in the Gironde region.

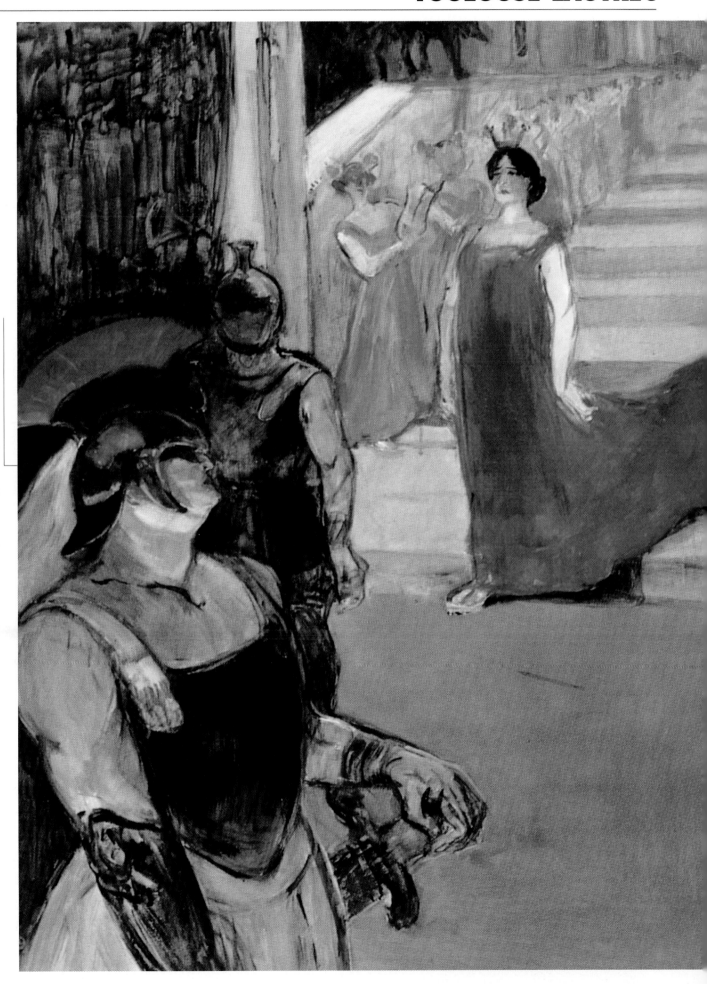

◆ MAURICE JOYANT IN THE BAY OF SOMME (1900, Albi, Musée Toulouse-Lautrec). This portrait of his dearest friend, based on a small preparatory painting done in May 1900 in the Bay of Somme, required 72 sittings and the artist was still dissatisfied. Joyant is portrayed dressed for cormorant hunting.

◆ MESSALINE DESCENDING THE STAIRS SURROUNDED BY WALK-ONS (1900-01, Los Angeles County Museum). In the rediscovered taste for historical paintings, this one by Toulouse-Lautrec shows a scene from *Messaline*, a four act tragic opera by Armand Silvestre and Eugène Morand that the artist saw in Bordeaux. The story is that when the actress came on stage he exclaimed: "She's divine!" and shut himself in for two days, drawing.

◆ THE MILLINER (1900, Albi, Musée Toulouse-Lautrec). At the end of the nineteenth century there were more than 2,400 milliners in Paris. It has been claimed that the artist's friends took him to the fashion shops on the rue de la Paix to distract him from drinking. The portrait on the left, showing the model Croquesi-Margouin, is considered his best work.

SIGNS OF MODERN FRANCE

The technique elaborated by the Japanese drawing masters, characterized by flat chromatic surfaces and particular subjects, influenced the Impressionists and, later, Vincent Van Gogh, Paul Gauguin and Henri de Toulouse-Lautrec. Japanese prints were collector's items in Paris around 1860, and became known to the general public at the 1867 Universal Exposition.

● The effects of sunlight on objects and persons were first analyzed and faithfully reproduced by Claude Oscar Monet (1840-1926). His 1866 painting *Women in a Garden* became one

of the guiding themes of Toulouse-Lautrec's early formation. Exhibited in 1874 with works by Pierre Auguste Renoir (1841-1919), Alfred Sisley (1839-1899), Edgar Degas (1834-1917), Camille Pissarro (1830-1903) and Paul Cézanne (1839-1906), his 1872 painting, *Impression, Rising Sun* gave the name to the Impressionist movement. Impressionism abandoned the traditional linear representation of figures in an attempt to capture the fleeting

effects of light and color using slight touches of the brush. This was the great turning point in European painting, the first step toward modernism, seized and carried forward above all by Toulouse-Lautrec and Cézanne.

● Dancers, working-women, and cabaret artists are the principal subjects in Edgar Degas's works. He used a great variety of techniques and was influenced by Muybridge's photographs of ballerinas in the theaters and race horses at the tracks. He was one of the precursors of Toulouse-Lautrec's painting.

● In France mural painting made a comeback thanks to Pierre Puvis de Chavannes (1824-98), whose monumental style and subdued colors, as in *The Sacred Wood* (1865-69), exercised a remarkable influence on the end of the century Symbolist painters and proved to be one of Toulouse-Lautrec's great teachers.

● Symbolist art, affirmed in 1886, tried to avoid current reality by appealing to the imagination and senses. In France its principal exponents were Gustave Moreau (1826-98) and Odilon Redon (1840-1916). The latter applied his fantastic imagination in his illustrations for Baudelaire's (1890) *Fleurs du Mal*.

● Paul Cézanne (1839-1906), whose extraordinary works were contemporary to those of Toulouse-Lautrec, distanced himself from Impressionist aesthetics in works like *L'Estaque* (1882-85), achieving an almost abstract expressivity with the accent on form and color.

● Meanwhile, Georges-Pierre Seurat (1859-91), Paul Signac (1863-1935) and Camille Pissarro (1830-1903) developed *Pointillisme*. This painting technique created the optical effect of light passing through a myriad of small dots of color. Analogously, Toulouse-Lautrec did his paintings with a quick, neurotic juxtaposition of colored commas.

◆ LEONETTO CAPPIELLO
Yvette Guilbert
(1899, Paris,
Musée Carnavalet).
The "reciter"
in one of her
characteristic poses.
In her 1927 *Memoires*
Guilbert gives a
definition of her style:
"I followed an
impression of extreme
simplicity, which
adapted very
harmoniously to
the lines of my thin
body and small head.
I wanted above
all to appear
very refined."

◆ PIERRE PUVIS
DE CHAVANNES
The Sacred Wood
(1887-89,
Paris, Sorbonne).
Toulouse-Lautrec
met and came
to appreciate Puvis
de Chavannes
at Cormon's studio.
Specialized in
monumental
paintings, Puvis used
a technique of flat
colors, without
shadow or relief,
often applied to long,
narrow panels.
His lesson was
taken up by
the Symbolist
painters. On the left
is the Symbolist
painter Odilon
Redon.

◆ GEORGES SEURAT
Model
(1886-88, Paris,
Musée d'Orsay).
This picture is one
of a series
of three panels that
comprise
the quintessence
of his art. The technical
perfection is worthy
of a miniaturist,
and the rigorous
scientific study does not
in any way compromise
the poetry of the figure,
which bears witness
to the artist's
classical spirit. A master
of the *Pointillisme*
technique, Seurat,
like Toulouse-Lautrec,
died very young,
only 32 years old.

◆ LEONETTO
CAPPIELLO
Yvette Guilbert
(1899, Paris,
Musée Carnavalet).
This small statue is
Yvette Guilbert,
the favorite
subject of artists,
writers, journalists
and caricature
painters at the end
of the nineteenth
century. She admitted
that her characteristic
hairstyle was
inspired by
a famous wax
head in the Lille
Museum.

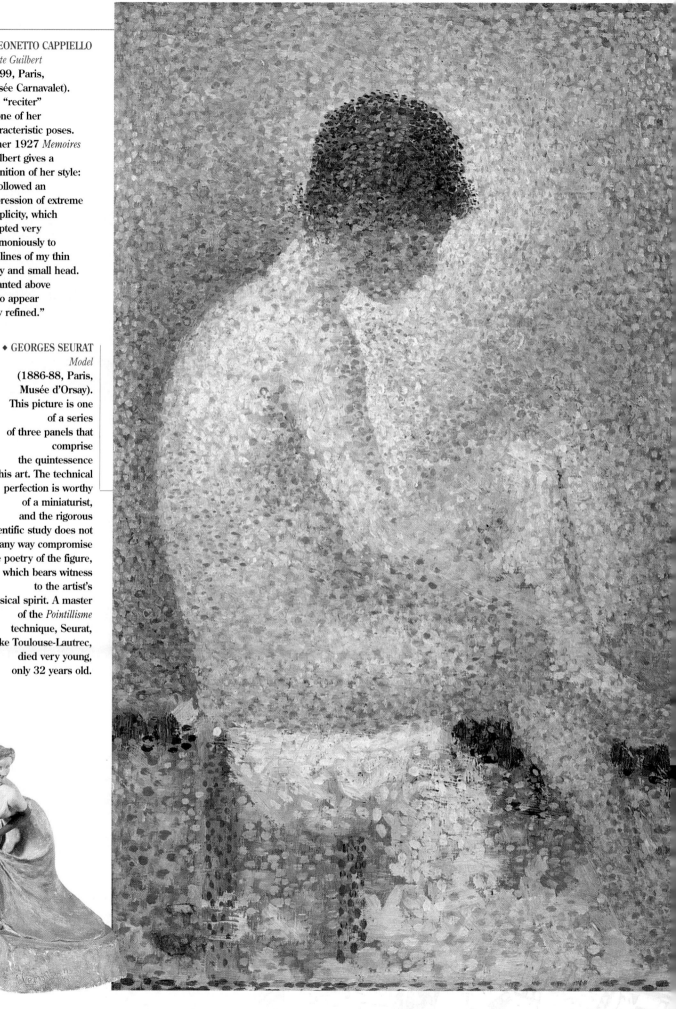

A MASTER OF THE HISTORICAL AVANT-GARDE

"I am not regenerating French art at all and I fight against a miserable sheet of paper that hasn't done anything to me and on which, believe me, I can't do anything good." Henri de Toulouse-Lautrec wrote this in a letter to his grandmother on December 28, 1886. When he died the death notices included criticisms, even hostile words, by those who severely condemned his life beyond the confines of orthodox society. "In Montmartre," someone observed, "there is no bar-boy, waiter, *maître d'hôtel* or woman who doesn't know this deformed dwarf of proverbial generosity."

● Henri de Toulouse-Lautrec's painting was the source of in-

◆ GIACOMO BALLA
Dynamism of a Dog on a Leash
(1909, Buffalo, Albright-Knox Art Gallery). Balla was one of the major exponents of Futurism, the movement that inaugurated avant-garde art; he studied Toulouse-Lautrec's work in Paris in 1900.

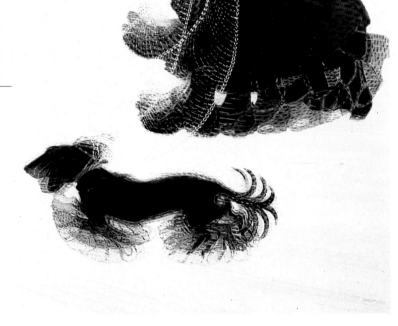

spiration for the decorative arts, and in the early twentieth century his color range was adopted by the German Expressionist painters.

● The artist's character, his physical defects, and aristocratic origins distracted critics for a long time from objective evaluation of his works. The *demi-monde* in which he deliberately chose to live kept him away from immediate success. His work has been seen by subsequent artists as a collection of aphorisms, in pocket form.

● Edvard Munch (1863-1944) was inspired by his strongly expressive, violent, arbitrary colors and his simplification of form, in parallel with his search for a more harmonious chromatic effect. Pablo Picasso (1881-1973) took up his subjects, those from the circus, the parties, the women, and made them into martyrs, humble, poor, alienated personages. Giacomo Balla (1871-1958) studied his posters and designs - the most creative of the early twentieth century - to begin the renewal of form in Futurism.

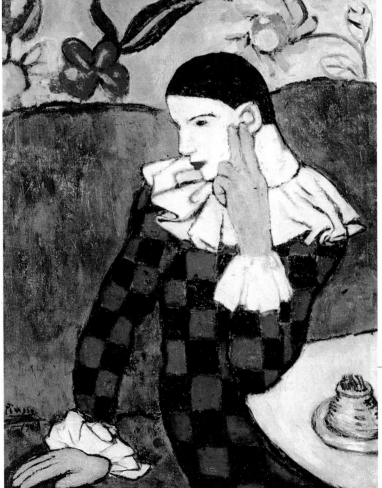

◆ PABLO PICASSO
Pensive Harlequin
(1901, New York, Metropolitan Museum of Art). Picasso dealt with this theme often, borrowed from the circus world in Toulouse-Lautrec's paintings. Harlequin takes part without conflict in the events of daily life. The human seriousness of the face is the expression of the sufferings of the disinherited, the humiliated.

◆ DANCING CHOCOLATE (1896, Albi, Musée Toulouse-Lautrec). This drawing in ink, blue pencil and charcoal, published in *Le Rire* on March 28, 1896, refers to the show of a black dancer who performed for regular clients at the *Bar d'Achille* in rue Royal. Here he is singing *"Sois bonne oh ma chère inconnue,"* accompanied by a lute. The lively chronicle of Paris night life with its cabarets, bars, theaters in Toulouse-Lautrec's works fascinated the world of the twentieth century. Even the world of cinema, the great Hollywood productions of the 1950s, adapted ideas from the artist's pictures: below, a frame from the movie *An American in Paris*, with the actor-dancer Gene Kelly, shows an explicit reference to the choreographic movement depicted in Henri de Toulouse-Lautrec's *Dancing Chocolate.*

GENE KELLY

THE ARTISTIC JOURNEY

This chronological summary will give the reader an overall view of Toulouse-Lautrec's artistic works

◆ ALPHONSE DE TOULOUSE-LAUTREC DRIVING HIS CARRIAGE (1880)
This painting, signed at the bottom right *"HTL Souvenir de la Promenade des Anglais, Nice 1880,"* is now at the Musée du Petit Palais in Paris. The scene takes place in Nice, where young Henri stayed because the mild climate was good for his delicate health. The thrust of the horses appears inspired by Gericault's works.

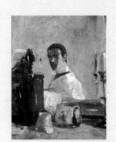

◆ SELF-PORTRAIT AT SIXTEEN (1882-83)
Lautrec rarely did self-portraits. In this panel, now at the Musée Toulouse-Lautrec in Albi, the artist evidences a certain detachment towards himself, presenting a description beyond the usual concepts of portraiture, as if he were an outside viewer. Resemblance is secondary. The artist uses the environment to characterize himself.

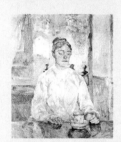

◆ COUNTESS ADÈLE DE TOULOUSE-LAUTREC (1883)
From 1879 to 1886 the young Henri did many portraits of his mother, to whom he was strongly attached. She is always portrayed with her eyes lowered, a sign of reserve and refined up-bringing. The hieratic pose in this painting, now at the Musée Toulouse-Lautrec, in Albi, recalls the Madonnas with Child.

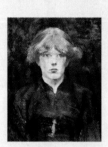

◆ CARMEN (1884)
Carmen Gaudin was not a professional model, and she had neither the posture nor the affected manner and indifference. Lautrec, who met her in Montmartre, dressed like a simple working-girl, was taken with her. Sullen, she appears unhappy about being portrayed. The almost symmetrical full-front perspective is contrasted by the direction of her glance.

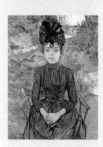

◆ JUSTINE DIEUHL SITTING IN THE FOREST GARDEN (1889)
In his portraits the artist searched for the deep psychology of his models, and he portrays their full humanity. There is also a certain humor, as in this painting, now at the Musée d'Orsay in Paris, where Justine sits enthroned, awkward and rigid, on a not very stable folding-chair.

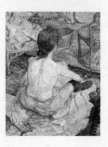

◆ THE REDHEAD (*LA TOILETTE*) (1889)
No preliminary drawings have been found for this picture, oil and turpentine on cardboard, which suggest that it was drawn from life. Toulouse-Lautrec first outlined the figure in dull blue-violet, then continued brightening the dark colors with touches of lighter shades. The painting is in the Musée d'Orsay in Paris.

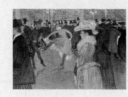

◆ VALENTIN-LE-DÉSOSSÉ TRAINING THE NEW GIRLS (1889-90)
When he entered the *Moulin Rouge* Toulouse-Lautrec was suddenly immersed in the *café-chantant* atmosphere, one of the modern subjects he loved to portray. This painting, now at the Museum of Art in Philadelphia, was ready at the end of March 1890 for exhibition at the *Salon des Indépendants* in Paris.

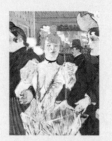

◆ GOULUE ENTERING THE MOULIN ROUGE (1892)
In this painting, now at the Museum of Modern Art in New York, the three women seem so close to the viewer that one almost feels the need to let them pass. But the artist puts them on show: the hair, the lipsticks, and the low neckline reveal that they belong to the *demi-monde*.

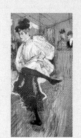

◆ JANE AVRIL DANCING (1892)
The full-skirted white muslin dress with high collar and puffed sleeves characterize the dancer Jane Avril in this painting on cardboard now at the Musée d'Orsay in Paris. Her left leg is lifted in one of the choreographic steps most fascinating to her admirers. Behind the dancer a couple in caricature are watching the show.

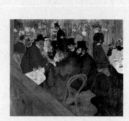

◆ AT THE MOULIN ROUGE (1892-93)
This painting, now at the Chicago Art Institute, shows some of the artist's friends (in the background with his cousin Tapié de Céleyran). Around the table are, from left, the dandy literary figure Edouard Dujardin, La Macarona, Paul Sescau and Maurice Guibert. The woman seen from behind fixing her hair is probably the dancer Jane Avril.

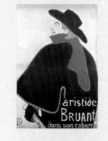

◆ ARISTIDE BRUANT IN HIS CABARET (1893)
Bruant was the star of one of the most chic *café-chantants* on the Champs-Elysées: *Les Ambassadeurs*. Henri de Toulouse-Lautrec did this lithograph, using four colors with brush and spray. Now at the Musée Montmartre in Paris, this was the final proof without text for the great poster so well appreciated by Bruant himself.

◆ STUDY OF "LOÏE FULLER" (1893)
This famous study, now at the Musée Toulouse-Lautrec in Albi, is part of a series of lithographs on the same subject done using the turpentine dilution technique. The swift brushstrokes translate the light, dynamic movements of the dancer, famous for her choreography with a hurricane of materials and vortex of skirts.

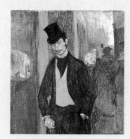

◆ GABRIEL TAPIÉ DE CÉLEYRAN IN A THEATER CORRIDOR (1893-94)
Gabriel, Toulouse-Lautrec's first cousin, came to Paris in 1891 to study medicine; he introduced Henri to a group of doctors. The artist in turn introduced his cousin to the Parisian world of nightlife. This portrait is now at the Musée Toulouse-Lautrec in Albi.

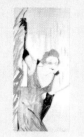

◆ YVETTE GUILBERT GREETING THE AUDIENCE (1894)
This painting, now in the Musée Toulouse-Lautrec in Albi, was done from an enlarged photograph in Yvette Guilbert's album. Her thin body, thin lips, and black gloves gave the "reciter" Yvette Guilbert a much admired bat-like air. She was perhaps the best loved star because of her refinement.

◆ YVETTE GUILBERT'S BLACK GLOVES (1894)
In this small oil painting, now at the Musée Toulouse-Lautrec in Albi, the artist synthetically expressed Yvette Guilbert's personality in her most characteristic accessory: a pair of long black gloves. The childhood memory of those worn by one of her governesses may have been her stimulus for wearing them, and they became a characteristic of her image.

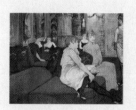

◆ AT THE SALON IN RUE DES MOULINS (1894)
An important expression of the brothel theme, this large painting, now at the Musée Toulouse-Lautrec in Albi, was carefully prepared with numerous preliminary drawings. The picture was exhibited with reservations, precisely because of the sensitive subject, at the Manzi-Joyant Gallery in Paris in 1896.

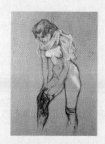

◆ STUDY OF "WOMAN PUTTING ON STOCKINGS" (1894)
Obviously done from life and then finished in the studio, this picture remained a drawing, now at the Musée d'Orsay in Paris. The quick diagonal brushstrokes express great energy; the arms, a key element in the picture, are curiously only sketched. This technique derives from Cormon's teachings.

◆ MOORISH DANCE (1895)
Henri de Toulouse-Lautrec portrayed Goulue's show with the tent in this oil on canvas now at the Musée d'Orsay in Paris. The belly-dance became popular with the shows at the Moroccan and Egyptian pavilions at the 1889 Universal Exposition in Paris. The audience portrayed in the picture includes, at the bottom, Tapié de Céleyran, Oscar Wilde and Félix Fénéon.

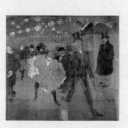

◆ DANCE AT THE MOULIN ROUGE
(GOULUE AND VALENTIN-LE-DÉSOSSÉ) (1895)
The scene is reminiscent of the time when Goulue excelled in "naturalistic quadrilles." In this oil painting, now at the Musée d'Orsay in Paris, the artist contrasts the agile, angular figure of the male dancer with Goulue's rounded features.

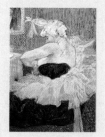

◆ LA CLOWNESSE CHA-U-KAO (1895)
Struck by her exotic character and costumes, Toulouse-Lautrec did many portraits of this woman with the enigmatic name. This painting on cardboard, now at the Musée d'Orsay in Paris, portrays the woman with a grotesque tuft of hair tied with a ribbon, sitting on a sofa in her dressing room fixing her bodice before going on stage.

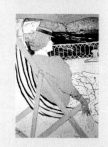

◆ THE PASSENGER IN CABIN 54 (1896)
This eight color chalk, brush and spray lithograph, now at the Musée de l'Affiche et de la Publicité in Paris, whose title was used in an Agatha Christie novel, regards one of the most important events in the artist's life: he was thunderstruck by the passenger in cabin 54 on the cargo ship *Chili* on his way to Le Havre in 1895.

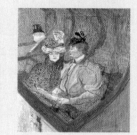

◆ STUDY FOR "THE BIG BALCONY" (1896)
This is a meticulous study for a series of lithographs: 12 copies printed in January 1897 and sold for 60 francs each. The personages are, left to right, the Rothschild's carriage driver Tom, whom Toulouse-Lautrec saw daily at the *Irish Pub* in rue Royale, the dancer-actress Emilienne d'Alencon, and Madame Armande.

◆ AT THE CIRCUS: FOOTIT,
THE TRAINER-CLOWN (1899)
The artist loved the circus theme. The elephant was for him an emblematic animal which he used often, especially in large decorative scenes. From late February to early March 1899 Lautrec was hospitalized in Dr. Sémelaigne's clinic, near a big circus.

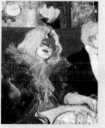

◆ PRIVATE ROOM AT THE RAT MORT (1899)
Now at the Courtauld Institute in London, this painting remained unknown during Toulouse-Lautrec's lifetime because it was never exhibited. He often went to the *Rat Mort* restaurant in the late 1890s. The man is an anonymous, secondary figure; the woman's face is illuminated from below, as taught by Degas.

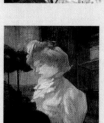

◆ THE MILLINER (1900)
At the end of the nineteenth century Paris had more than 2,400 milliners. Manet and Degas had already portrayed milliners at work. It is said that Toulouse-Lautrec's friends took him to the fashion houses in rue de la Paix to distract him from drinking. This painting, now in the Musée Toulouse-Lautrec in Albi, portrays this favorite aspect of the private world of women.

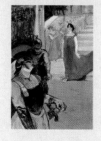

◆ MESSALINE DESCENDING THE STAIRS
SURROUNDED BY WALK-ONS (1900-01)
In his last years Henri de Toulouse-Lautrec rediscovered historical painting and chose to illustrate a scene from a four act lyrical tragedy set to music by Isidore de Lara, which he saw in Bordeaux. This oil painting, now at the Los Angeles County Museum, is one of his last works before his untimely death.

TO KNOW MORE

These pages present some documents useful for understanding different aspects of Toulouse-Lautrec's life and work,
the basic stages in his biography, technical details and the location
of the principal works presented in this volume, and an essential bibliography

DOCUMENTS AND TESTIMONIES

The Influence of Japanese Art

In his monograph on the artist, the art historian André Chastel emphasizes the influence of Japanese painting on the French Impressionists and post-Impressionists, evidencing how Toulouse-Lautrec's modern methods of expression were based on the Oriental technique.

"Lautrec stands out with irritating freshness in an environment that was more prone to vulgarity than had been seen for a long time, when the fat bourgeoisie showed off in Montmartre as elsewhere in the nineteenth century. Lautrec represented the revenge of the libertine eighteenth century (we know how much is implicit in this term, rich in cynicism, splendor and courage) against modern sluggishness, because this amateur artist suddenly decided to overthrow 'professionals' of all kinds and launched an irresistible counter-tendency. The small rich provincial who went at 18, in 1882, to the Parisian academies, getting to know the capital when Impressionism was at its triumph, had achieved ten years later that mastery of style already evident in his 1892 lithographs. His period of greatest success was around 1895; but when he died in 1901, at 37, Lautrec had had time to make a decisive mark on modern painting, taking it beyond any preceding formula, with the consequences that are well known […].

Lautrec found without effort that vague sense of mystery and essence which gives life to much Oriental art: a backward pose, a bare nape, studied hairstyles all fill a sort of void. It has been said, and two words suffice to remind one, that the ex-ample of Japanese engravings were the decisive confirmation that Lautrec may have needed: space was reduced to an oblique or horizontal line in a dilating or shrinking plane (in that world almost lacking in perspective) as a function of certain signs; color was freed of all burden of description (or rather tonal value), and it was thus possible to inscribe tones like the notes on a pentagram. If he had not studied Japanese works, Lautrec probably would not have achieved such total perfection of his expressive methods."

[A. Chastel, *Toulouse-Lautrec*, 1966]

A Unique Case in Art

Speaking of Henri de Toulouse-Lautrec's work, Dauberville dwells above all on the mystery of his early death and the interpretation of signs of destiny, comparing the artist to the greatest geniuses of painting and music.

"Toulouse-Lautrec is a unique case in art […]. It was he who first knew how to use cardboard, barely covering it, like the 'whites' in Cézannes watercolors. Everything seems to be invention with this curious talent: thanks to him posters became masterpieces of spirit and whimsy. Today we are used to new laws of plasticity, discoveries in optical illusions, ecstasy-producing glimpses; but then his posters were absolute audacity.

On everything he painted – horses, dogs, buggies, music-halls, portraits, even 'those women' – he left a powerful mark and trait that made him the most personal artist of the end of the nineteenth century […]. His death was premature: he seemed to want it; he did nothing to contain the ills, but to the contrary did everything possible to hasten the end.

He had lived enough; his genial message was finished, and he wanted eternal sleep; at 35, like Seurat. These two artistic giants died at the age when artists begin to acquire maturity of talent; like Mozart, they were privileged beings, marked by the heavens to be unequalled."

[H. Dauberville, *La bataille de l'Impressionisme*, 1967]

A Refined Education

De Montcabrier's memories of his friend Toulouse-Lautrec were published for the centenary of the artist's birth. The painter's refined, elegant character, always master of the situation, emerges from this testimony. The artist was thus rehabilitated following the widespread defamation by critics after his death.

"Lautrec maintained always the perfect courtesy and great gentility of his refined childhood education. I never heard him pronounce the most minimal curse, or use vulgar words in conversation. We can say that in this sense he lacked the training of boarding school or life in the barracks. If at times he was amused by the unexpected, expressive words in dialect used by his friend Aristide Bruant, he did not repeat them in the drawing rooms of wealthy old women or mother superiors. But he knew how to reply in tone, in the necessary language, to the pests who wanted to consider him a Barnum phenomenon, overtly and insultingly condescendent or with an ostentatious and pretentious superiority based on height, that permitted them to look down on Toulouse-Lautrec. Thus the majority of these 'illustrious gentlemen' waited for the artist's death to take revenge 'literally.' They took care not to do it while he was still alive."

[R. de Montcabrier,
Il y a 100 ans Henri de Toulouse-Lautrec, 1964]

HIS LIFE IN BRIEF

1864. At six in the morning on November 24 Henri-Marie-Raymond de Toulouse-Lautrec Monfa was born in the home of the d'Imbert du Bosc sisters, his great-aunts, in rue de l'Ecole Mage in Albi.

1872. The family moved to Palais Perey in rue Boissy, Paris. In October he attended the Lycée Fontanes.

1873. Saw his first puppet show at the Théatre Miniature. On June 19 he was separated from his mother for the first time.

1875. At Le Bosc, imitated his uncles who drew and painted.

1882. Introduced to Léon Bonnat and in September attended Fernand Cormon's studio at 10 rue Constance.

1883. Wrote reviews of the big exhibitions: the *Salon*, the *Exposition de la Société Internationale des Peintres et Sculpteurs*.

1884. Rented an apartment at 19 bis, rue Fontaine. Degas occupied the first floor in the same building from 1879 to 1891.

1886. Met Vincent Van Gogh who worked in Cormon's studio. In December he invited the Dutch artist to Aristide Bruant's show at the *Mirliton*.

1887. Participated in the *Exposition Internationale des Beaux Arts* in Toulouse under the pseudonym Treclau.

1888. Dealings with the art dealer Arsène Portier and Theo Van Gogh, Vincent's brother. In early February, exhibited works in Brussels with the group *Les Vingt*.

1890. On March 20, participated successfully in the inauguration of the sixth *Salon des Indépendants*, at the Pavillon de la Ville de Paris, exhibiting *Valentin-le-Désossé Training the New Girls* and the portrait *Mademoiselle Dihau*.

1891. Participated in the *Salon des Arts libéraux*. In June the gallery Goupil-Boussod and Valadon bought *The Corner of the Moulin Rouge* for 375 francs.

1896. Success with the German public. The critic Meier-Graefe bought four of Lautrec's prints from Vollard for six francs.

1900. Moved to Bordeaux where he lived at 66 rue Cauderan and rented a studio at 47 rue Porte-Dijeaux.

1901. Returned to Paris at the end of April to choose the works to be exhibited at the third Secession show in Berlin. On September 9 at two in the morning Henri de Toulouse-Lautrec died at the castle of Malromé.

WHERE TO SEE TOULOUSE-LAUTREC

*Below is a list of Toulouse-Lautrec's principal works on view in public collections.
The list is in alphabetical order of the cities where the works are located.
The information presented is: title, date, medium and base, dimensions in centimeters*

ALBI (FRANCE) - MUSÉE TOULOUSE-LAUTREC
Sketchbook, 1874-79; pencil drawings and watercolors, 12x19.

Horsemen Meeting for the Chase, 1878; watercolor, 22.7x13.7.

Artillery Soldier Saddling His Horse, 1878; oil on canvas, 50x37.

Self-Portrait at Sixteen, 1882-83; oil on panel, 40.5x32.5.

Countess Adèle de Toulouse-Lautrec, 1883; oil on canvas, 93.5x81.

Nude Study, 1883; oil on canvas, 55x46.

Louis Pascal, 1891; oil with turpentine on cardboard, 81x54.

Gabriel Tapié de Céleyran in a Theater Corridor, 1893-94; oil on canvas, 100x56.

Yvette Guilbert's Black Gloves, 1894; oil with turpentine on cardboard, 62.8x37.

Yvette Guilbert Greeting the Audience, 1894; black crayon, 21.8x16.2.

CHICAGO (UNITED STATES)
Horseback Rider at the Circo Fernando, 1887-88; oil on canvas, 103x161.3; Art Institute.

At the Moulin Rouge, 1892-93; oil on canvas, 123x141; Art Institute.

La Macarona, 1893; watercolor, 40x37; Art Institute.

COPENHAGEN (DENMARK)
Money, 1895; six colored lithographs with chalk, brush and spray, 31.9x23.9; Statens Museum for Kunst.

At the Circus: Footit, the Trainer-Clown, 1899; black pencil with colors, 25.9x43.3; Statens Museum for Kunst.

LONDON (GREAT BRITAIN)
Emile Bernard, 1886; oil on canvas, 54.5x43.5; Tate Gallery.

Jane Avril Entering the Moulin Rouge, 1892; oil and pastels on paper mounted on cardboard, 102x55; Courtauld Institute.

Japanese Divan, 1893; five colored lithograph with chalk, brush and spray, 78.8x59.5; British Museum.

Jane Avril at the Jardin de Paris, 1893; five colored lithograph with brush and spray, 124x91.5; British Museum.

Mademoiselle Eglantine's Ballet, 1896; three colored lithograph with chalk, brush and spray, 61.7x80.4; Victoria and Albert Museum.

NEW YORK (UNITED STATES)
Woman Smoking, 1890; black chalk, oil with turpentine and gouache on cardboard, 47x30; Brooklyn Museum.

Paul Sescau, 1891; oil with turpentine on cardboard , 82.5x35.6; Brooklyn Museum.

Goulue Entering the Moulin Rouge, 1892; oil with turpentine on cardboard, 79.5x59; Museum of Modern Art.

PARIS (FRANCE)
Alphonse de Toulouse-Lautrec Driving His Carriage, 1880; oil on canvas, 38.5x51; Musée du Petit Palais.

Gustave Lucien Dennery, 1883; oil on canvas, 55x46; Louvre.

The Redhead (*La Toilette***),** 1889; oil with turpentine on cardboard, 67x54; Musée d'Orsay.

Justine Dieuhl Sitting in the Forest Garden, 1889; oil with turpentine on cardboard, 74x58; Musée d'Orsay.

Woman with a Black Boa, 1892; oil with turpentine on cardboard, 52x41; Musée d'Orsay.

Jane Avril Dancing, 1892; oil with turpentine on cardboard, 85.5x45; Musée d'Orsay.

Aristide Bruant in His Cabaret, 1893; four colored lithograph with brush and spray, 133.5x96.6; Musée de Montmartre.

Dance at the Moulin Rouge (Goulue and Valentin-le Désossé), 1895; oil on canvas, 298x316; Musée d'Orsay.

Moorish Dance, 1895; oil on canvas, 285x307; Musée d'Orsay.

La Clownesse Cha-U-Kao, 1895; oil on cardboard, 54x49; Musée d'Orsay.

The Passenger in Cabin 54, 1896; eight colored lithograph with chalk, brush and spray, 61x41; Musée de l'Affiche et de la Publicité.

Paul Leclercq, 1897; oil with turpentine on cardboard, 54x64; Musée d'Orsay.

PHILADELPHIA (UNITED STATES)
Valentin-le-Désossé Training the New Girls, 1889-90; oil on canvas, 115x150; Philadelphia Museum of Art.

At the Nouveau Cirque: Clownesse with Five Shirt-fronts, 1892; charcoal, gouache and oil with turpentine on paper, 59.5x40.5; Philadelphia Museum of Art.

SÃO PAULO (BRAZIL)
The Wheel, 1893; black chalk and gouache on cardboard, 63x47.5; Museu de Arte.

At the Salon: The Divan, 1893-94; oil with turpentine, pastels, and charcoal on cardboard, 60x80; Museu de Arte.

WILLIAMSTOWN (UNITED STATES)
Carmen, 1884; oil on canvas, 52.8x40.8; Sterling and Francine Clark Art Institute.

ZURICH (SWITZERLAND)
At the Renaissance: Sarah Bernhardt in "Phaedra," 1893; lithograph with chalk, brush and spray, 34.2x23.5; Kunsthaus.

The Old Stories, 1893; five colored lithograph with chalk and spray, 44x63.5; Kunsthaus.

BIBLIOGRAPHY

For further knowledge of the various periods of his development, it is advisable to consult general catalogues of Toulouse-Lautrec's works.

1927 J. Lassaigne, *Toulouse-Lautrec*, Paris

1931 E. Vuillard, *Lautrec raconté par Vuillard*, Paris

1951 J. Adhémar, *Toulouse-Lautrec et son photographe habituel*, in *Aesculape*, Paris

E. Julien, *Les Affiches de Toulouse-Lautrec*, Montecarlo

1963 M. Tapié de Céleyran, *Notre oncle Lautrec*, Geneva

1964 J. Bouret, *Toulouse-Lautrec*, Paris

M. Dortu, *Toulouse-Lautrec paints a Portrait*, New York

1972 M. Dortu, *Tout Toulouse-Lautrec*, Paris

1973 P. Dupouy, *Toulouse Lautrec et la presse bordelaise*, in *Revue Historique de Bordeaux*, Bordeaux

1977 E. Lucie-Smith, *Toulouse-Lautrec*, Oxford

A. Balakian, *The Symbolist Movement. A Critical Appraisal*, New York

1978 G. Murray, *Toulouse-Lautrec et son œuvre*, in *Bollettino dell'arte*, Bordeaux

1979 C. Baxter, *Mistaken Identities: Three Portraits by Toulouse-Lautrec*, in *Print Collector's Newsletter*, London

1980 T. Reff, *Degas, Lautrec and Japanese Art*, in *Japonisme in Art. An International Symposium*, Tokyo

L. Broido, *The Posters of Jules Chéret*, New York

1984 R. Thompson, *Toulouse-Lautrec and Sculpture*, in *Gazette des Beaux-Arts*, London

1985 W. Wittrock, *Toulouse-Lautrec: The Complete Prints*, 2 vols., London

C. de Rodat, *Toulouse-Lautrec: album de famille*, Freiburg

1987 J. Rewald, *Postimpressionismo*, Milan

M. Arnold, *Henri de Toulouse-Lautrec*, Cologne

A. Griffiths, *The Prints of Toulouse-Lautrec*, London

R. Thompson, *Toulouse-Lautrec in Germany and Switzerland*, in *Burlington Magazine*, Oxford

M.G. Sugana, *Tutta l'opera di pittura di Toulouse-Lautrec*, Paris

1988 C. Angrand, *Correspondances, 1883-1926,* Lagny-sur-Marne

1989 E. Hanska, *La romance de la Goulue*, Paris

1990 A. Simon, *Toulouse-Lautrec*, London

R. Thompson, *Lautrec contre Lautrec*, Albi

L. Adler, *La vie quotidienne dans les maisons closes*, Paris

R.J. Goldstein, *Censorship of Political Caricature in Nineteenth Century France*, Kent-London

F. Caradec, A. Weill, *Les café-concerts*, Paris

J. Bailly-Herzberg, *Correspondances de Camille Pisarro*, Paris

1991 D. Devynck, *Art et Publicité*, Paris

I. Roquebert, *Catalogue sommaire illustré des peintures du Musée D'Orsay*, 2 vols., Paris

1992 *Toulouse-Lautrec*, exh. cat., London